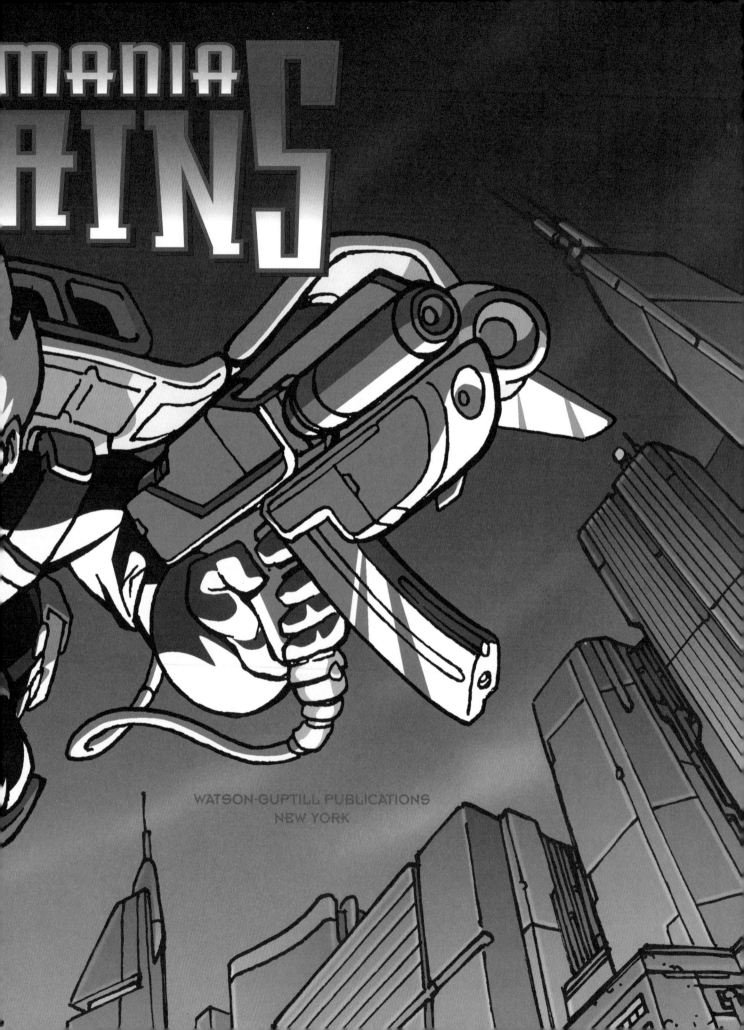

WATSON·GUPTILL PUBLICATIONS
NEW YORK

For Maria, Isabella,
and Francesca

SPECIAL THANKS TO:

BILL FLANAGAN,
and of course, to the people
at Watson-Guptill
for making this possible.

CONTRIBUTING ARTISTS:

Svetlana Chmakova: 78–95
Brian Denham: 41–61, 76–77
Lee Duhig: 2–3, 115–116, 118–121
Tim Eldred: 130, 136–143
Ale Garza: 7, 24–25, 28–29, 62–67, 70–75, 117
Christopher Hart: 1, 8, 14–15, 20–21, 30–43, 68–69, 133
J. J. Kirby: 16–19
Andy Kuhn: 6, 96, 107–113, 131–134
Mike Leeke: 122–129
Ruben Martinez: 10–13, 22–23, 26–27, 97–106, 114, 117

Cover art by Pop Mhan,
based on a drawing and
concept by Brian Denham

Color by MADA Design, Inc.

Senior Editor: Candace Raney
Project Editor: Alisa Palazzo
Designer: Bob Fillie, Graphiti Graphics
Production Manager: Ellen Greene

Copyright © 2003 Star Fire, LLC

First published in 2003 in the United States
by Watson-Guptill Publications
a division of VNU Business Media, Inc.
770 Broadway, New York, NY 10003
www.wgpub.com

Library of Congress Cataloging-in-Publication Data
Hart, Christopher.
 Manga mania villains : how to draw the dastardly characters
 of Japanese comics / Christopher Hart.
 p. cm.
 ISBN 0-8230-2971-9 (pbk.)
 1. Comic books, strips, etc.—Japan—Technique. 2. Villains—Caricatures
 and cartoons. 3. Drawing—Technique. I. Title.
 NC1764.5.J3 H3694 2003
 741.5—dc21
 2003002402

Manufactured in the United States of America

3 4 5 6 7 8 / 10 09 08 07 06 05 04

VISIT US AT

www.artstudiollc.com

CONTENTS

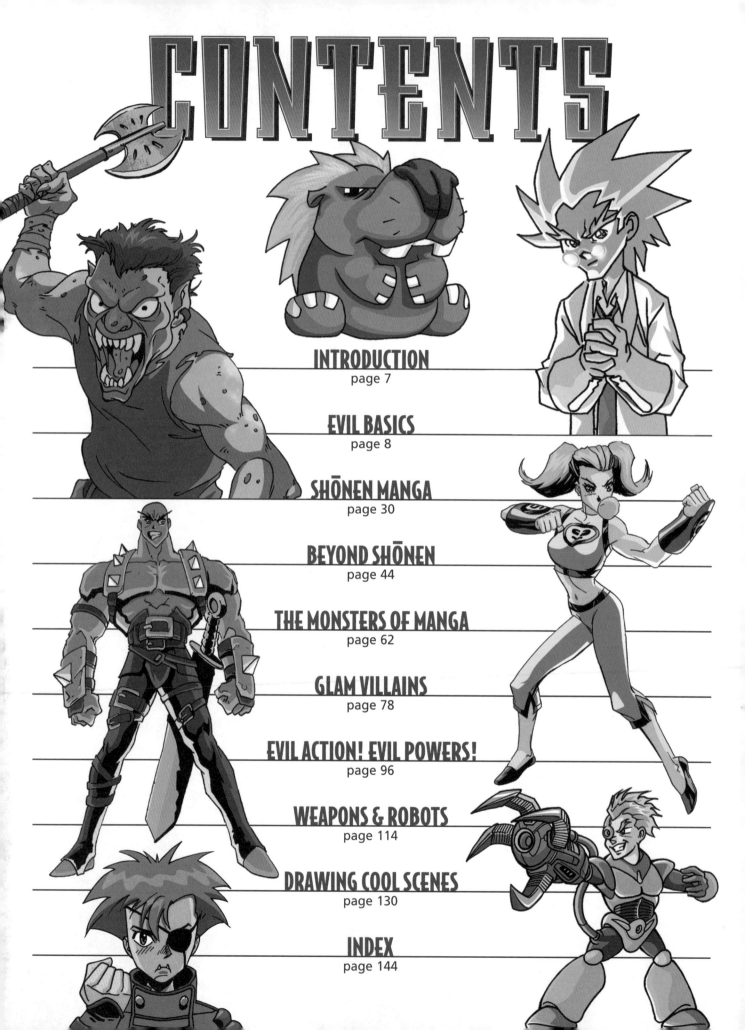

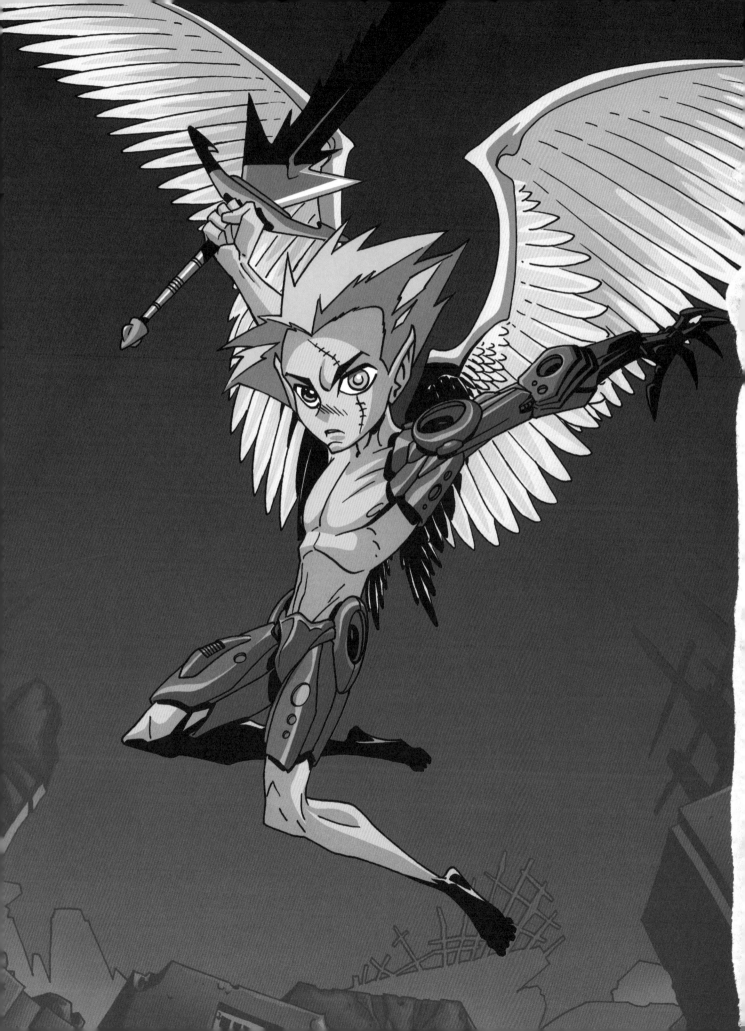

INTRODUCTION

What do the most exciting stories and awesome battles have in common? Great villains. There's no substitute. Bad guys drive the story, and the good guys react. Heck, we all love bad guys. The "badder," the better. What would a fight scene look like with a wimpy bad guy? However, if that bad guy is an insane maniac with special powers, you'll have millions of fans tuning in every afternoon.

Bad guys aren't fettered by social norms or restrictions. They're over-the-top, flamboyant, and ruthless. We hate to admit it, but without them, life would get pretty dull in *manga* and *anime.* The villains provide the spice, the flavor, the *flair.*

Manga's bad guys are in a class by themselves. As the center of attention, they deserve special treatment by artists learning to draw manga and anime. Do you know, for instance, how to draw villainous eyes? Did you know there are four basic types of evil eyes for men and four different ones for women? Would you like to know how to design costumes for bad guys? Did you know that bad guys fight differently than good

guys? They use dirty tactics, which you'll learn in the chapter "Evil Action! Evil Powers!" Exactly how do you use shadows to create a sinister look? Did you know that the bigger your drawing is, the more shadow you should use? All that and much more is in this book.

The techniques used by the pros to make their villains mesmerizing and memorable have, for the most part, remained secret—until now. We're going to blow the lid off these secrets for the first time. We'll focus like a laser beam on the most popular genres of manga, such as the famous *shōnen* style—the most popular category of manga, which features lots of action. We'll also zero in on glamour villains, medieval bad guys, big monsters, little monsters, fantasy weapons, and even evil giant robots or *mecha*—an extremely popular genre in Japanese comics.

So if you want to draw really cool, diabolical bad guys, this will be a valuable resource for you. Since the job of this book is to give you ideas and the tools to realize them, soon you'll be designing your own world-class villains. Ready to rule the universe? Turn the page and let's go!

EVIL BASICS

If you think a beginning chapter, like this one, will be kind of dull, think again. We're learning to create world-class villains, so every technique is packed with attitude. To lay down a strong foundation, we'll cover heads, expressions, and bodies. Then we'll build on this in the following chapters. It's best to follow the steps, but you don't have to be a slave to them. If you want to skip a step or make changes to the final drawing— for example, by altering a nose—go ahead and do it.

Typical Evildoers

If you think about your favorite manga stories and anime episodes, you'll probably find yourself remembering the ones with the best villains. The bad guys bring flash and sizzle to the picture. Yep, they've got an attitude, just like the ones pictured here. And, since every good manga comic book has villains, I've included just about every kind in this book. So, no matter what style you love, something evil is here for you.

Bad Guy Head

You don't have to begin with an outrageous drawing to end up with a decent bad guy. Even the most wicked of manga villains has a fairly simple—even ordinary—head shape. Typically, the head is big on top and narrow at the bottom. Also, the face is full, without protruding cheekbones.

So, what makes these dastardly characters so cool looking? It's their dazzling eyes, expressive facial features, and high voltage hairstyles. Let's begin by drawing the basic head.

FRONT VIEW

The front view often gives beginning artists problems, and here's why: It's difficult to make the nose appear as if it's protruding from the face when you're looking straight at it (a view in which it appears flattened out). Here's the good news: Manga characters have subtle noses, so all that's really required in the front view is a tiny cast shadow of the nose. And that's easy to draw. But the most important thing to remember when drawing any character in the front view is to line up the eyes and ears so that they are at the same level.

The typical manga villain's head is large on the top and small on the bottom, like an egg. It helps to lightly sketch in a vertical guideline that bisects the head and three horizontal guidelines just below the midway point for the features.

Along the guidelines, evenly position the eyes and ears, and begin to sketch in the nose shadow and mouth. Note the heavy eyebrows, which are great for bad guys.

Give those eyes multiple shines if you want your villain to really stand out. And send him to a maniac hair stylist.

Thin lips are the hallmark of villainous characters. Add some special effects, and you're ready to unleash the forces of evil.

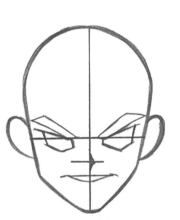

SIDE VIEW

The profile emphasizes the famous, upturned nose of manga characters. The outward curve of the forehead changes direction at the bridge of the nose and begins its curve inward. After the nose, the face slopes inward to a receding, yet pointed, chin.

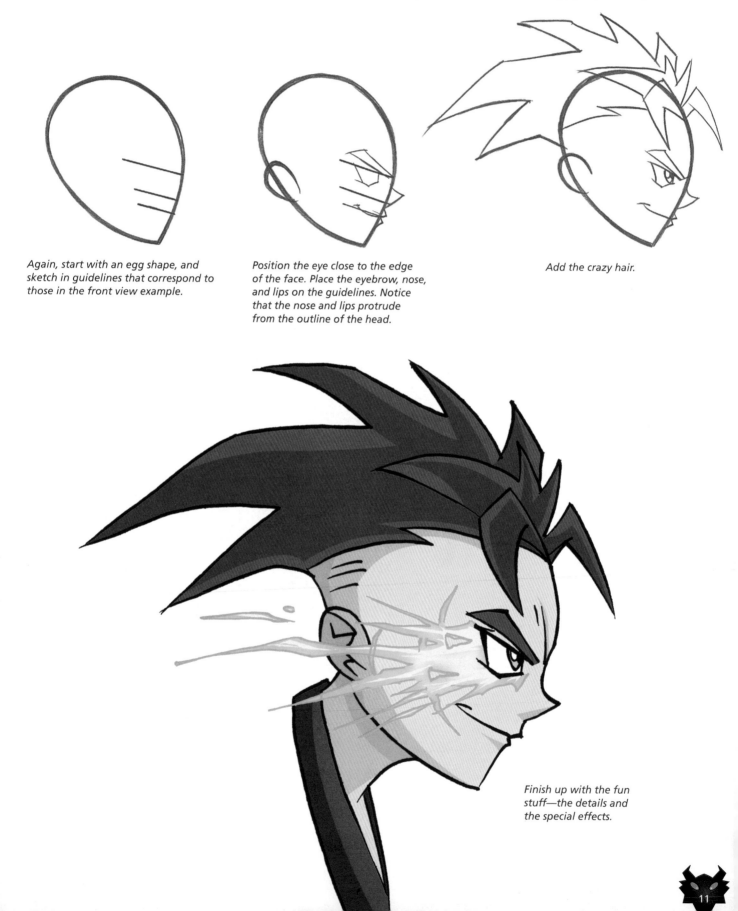

Again, start with an egg shape, and sketch in guidelines that correspond to those in the front view example.

Position the eye close to the edge of the face. Place the eyebrow, nose, and lips on the guidelines. Notice that the nose and lips protrude from the outline of the head.

Add the crazy hair.

Finish up with the fun stuff—the details and the special effects.

The Bad Gal Head

Your mom warned you not to go out with a girl like this. But she never said you couldn't draw her. This character looks complicated, doesn't she? Actually, she's no more difficult to draw than the guy on the preceding page. It's only the details—the fiery hair and facial markings—added in the fourth step that give her that extravagant look. (As a general rule of thumb, villains are extravagant; good gals are simple.) Underneath all of that gift wrapping, she's really a simple character.

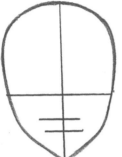

Start off with a simple oval shape and some guidelines like those shown on page 10. Simple shapes can evolve into awesome characters.

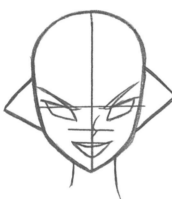

Note the tilt of the eyes, which makes them look catlike. The eyebrows are drawn at sharp angles, too. Now she's looking evil.

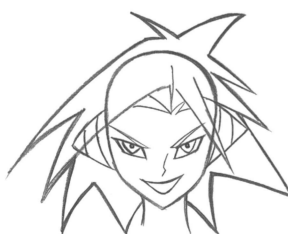

Crazy hair. The crazier the hairstyle, the better.

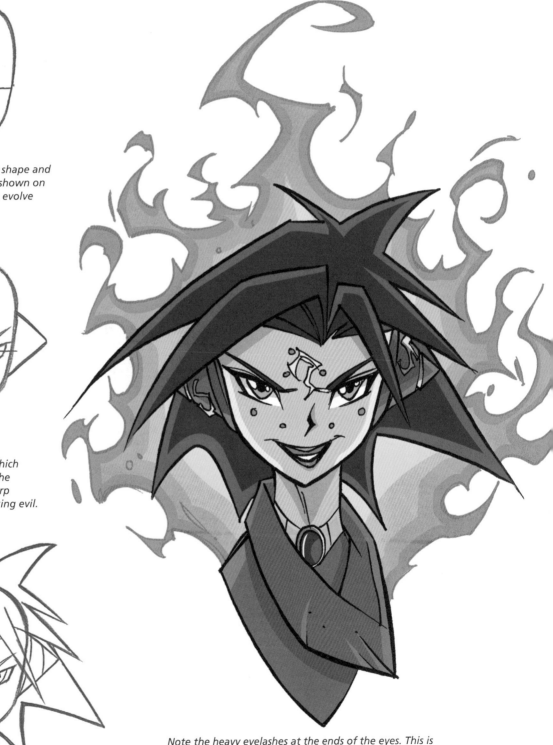

Note the heavy eyelashes at the ends of the eyes. This is essential for making an impact. Create over-the-top special effects, like the ones behind this character. That's the way we like it in manga. There's nothing dull about this gal.

Drawing the same character from different angles is extremely important for the development of any artist. If you're only comfortable drawing one angle, you will unnecessarily limit yourself and what your characters can do. By practicing the poses in this book, you'll have drawn almost every conceivable angle without even thinking about it!

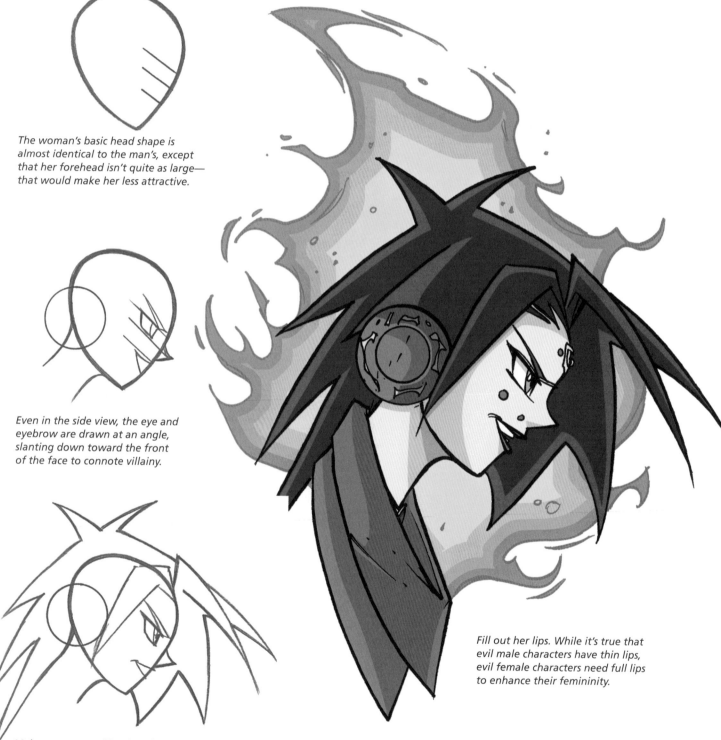

The woman's basic head shape is almost identical to the man's, except that her forehead isn't quite as large—that would make her less attractive.

Even in the side view, the eye and eyebrow are drawn at an angle, slanting down toward the front of the face to connote villainy.

Make sure some of her hair falls in front of her face, which makes her more attractive. The upper eyelid is elongated and thickened, to mimic eyelashes.

Fill out her lips. While it's true that evil male characters have thin lips, evil female characters need full lips to enhance their femininity.

Evil Eyes: The Men . . .

Evil eyes are like a trademark. Only villains have 'em. Drawing eyes with an angry frown isn't quite enough. If you want to make your character *bad* and not just angry, if you want him slightly *crazy* and not just having a bad hair day, then here are the simple tweaks you need to make.

Note that there's no single eye style that's right for all bad guys. The shape of the eyes and the eyebrows will differ from character to character. However, there are four basic types.

BIG SHINES
The big-eyed look, with plenty of shines, requires heavy eyebrows; otherwise, the expression will look weak.

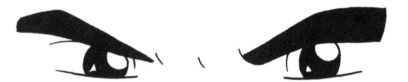

DARKLY GLISTENING
These shines take up less space in the iris as compared to the first example, making the eyes look darker and giving the expression a menacing feel.

BEADY
Reduce the size of the pupils to small beads, and leave them hollow. This gives your character a maniacal look.

PIERCING
Tiny pupils inside of small irises create a chilling look of a pure evil.

HINT
Give a villain very dark lower eyelids. It'll make him look sinister! And put some scratchy shading under his eyes and across the bridge of his nose, too.

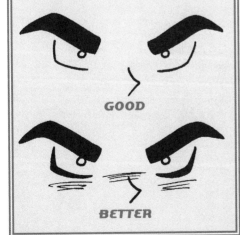

GOOD

BETTER

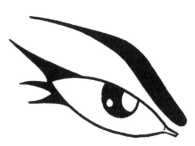

...and the Women

There's an equally wide variety of evil eye styles for female characters. You can go as bold as you like with the eyebrows and, especially, the eyelashes. Here are the four basic types.

STANDARD VILLAINESS

Almond-shaped eyes tilt upward at the ends, complemented by heavy eyelashes grouped into only two or three actual lashes. The eyebrows are thick and dramatic.

SINGLE EYELASH

Use a heavy line to create an eyelid that tapers into a single eyelash. The eyeballs should be halfway hidden beneath the eyelid for a sultry look.

BIG-EYED LOOK

Multiple shines are very popular in manga and are best used when the eyes are enlarged; this way, the eye can hold all the shines without looking cluttered. Choose an eye shape that's boxy rather than slender, creating ample room for the shines.

GRADATED

This is a cool look that's more realistic. Draw a series of horizontal lines across the bottom of the eyes to give a richer look. And, in keeping with the added realism, show more lashes and even indicate the fold over the eyes (the line between the eyebrow and the upper eyelid).

HINT

When drawing villainous women's eyes, tilt the ends up in a catlike manner and then add lower eyelashes, too.

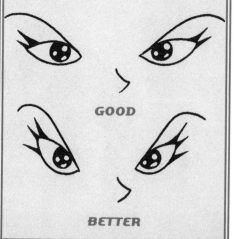

GOOD

BETTER

15

Expressions: Good Guys vs. Bad Guys

Good guys react very differently to things than villains do. A good guy looks at a charming town and smiles because it's wholesome. A bad guy looks at the same town and smiles because it's ready to be corrupted. Both are smiles, but each smile has a different meaning and a different expression.

GOOD GUY

BAD GUY

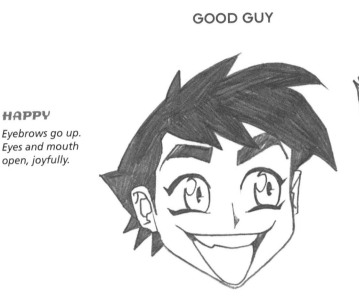

HAPPY

Eyebrows go up. Eyes and mouth open, joyfully.

HAPPY

Eyes narrow, but never shut—he trusts no one! Thin eyebrows form a slight frown. He looks out of the sides of his eyes. The mouth widens into a sinister grin, with teeth showing.

PLEASED

The eyes are open, and the mouth forms a small smile. The eyebrows are natural.

PLEASED

He's happy because of something bad he's planning to do. The eyebrows crush down on the eyes, which narrow considerably. The mouth widens into a tight smile that curls up at the ends.

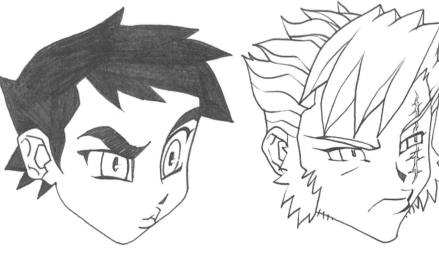

CURIOUS

One eye is narrow while the other is wide, as he takes a hard look at something that doesn't seem quite right.

CURIOUS

Both eyes are narrow. The mouth shows more disappointment. Bad guys don't handle disappointment well. They're overly emotional.

GOOD GUY BAD GUY

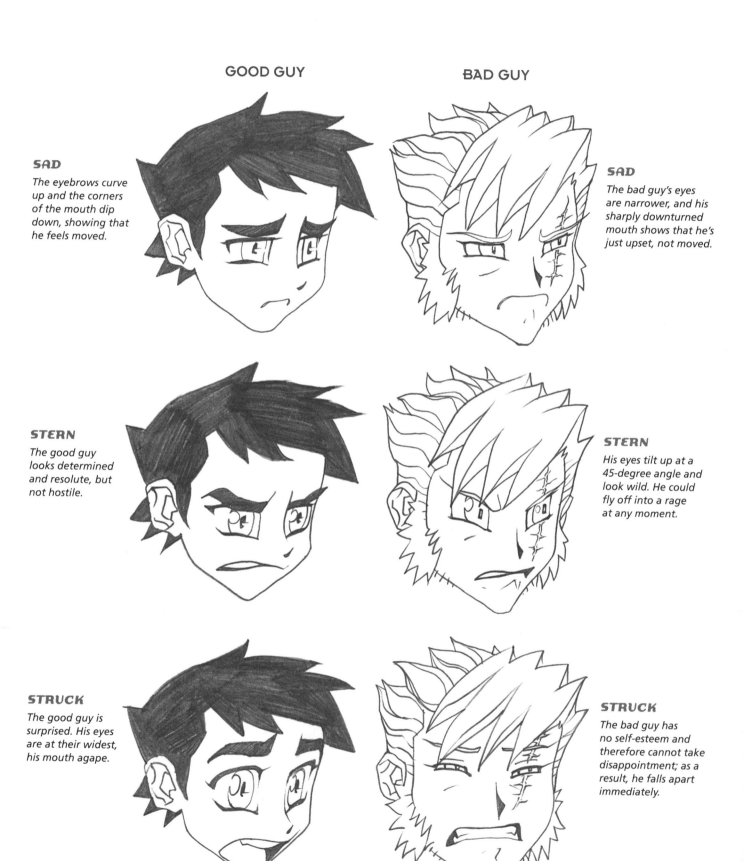

SAD

The eyebrows curve up and the corners of the mouth dip down, showing that he feels moved.

SAD

The bad guy's eyes are narrower, and his sharply downturned mouth shows that he's just upset, not moved.

STERN

The good guy looks determined and resolute, but not hostile.

STERN

His eyes tilt up at a 45-degree angle and look wild. He could fly off into a rage at any moment.

STRUCK

The good guy is surprised. His eyes are at their widest, his mouth agape.

STRUCK

The bad guy has no self-esteem and therefore cannot take disappointment; as a result, he falls apart immediately.

17

Expressions: Good Gals vs. Bad Gals

It used to be that the term "bad girl" meant a comic book character who would try to seduce the hero. But today, the definition has grown to include power-mad—and just plain evil—women, too. As a result, today's bad girl has a wide array of emotions.

GOOD GAL BAD GAL

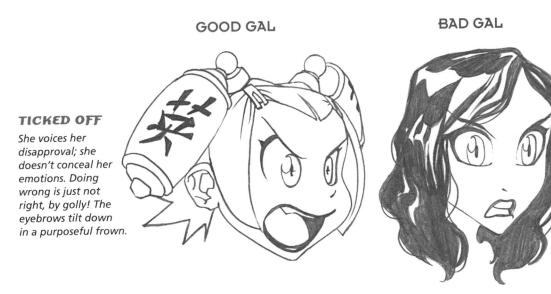

TICKED OFF

She voices her disapproval; she doesn't conceal her emotions. Doing wrong is just not right, by golly! The eyebrows tilt down in a purposeful frown.

TICKED OFF

She's stunned. She can't imagine that things aren't going her way. Any snag in her plans causes huge frustration. She looks wide eyed in disbelief.

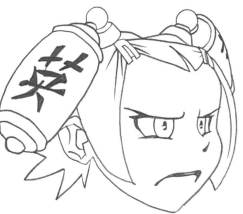
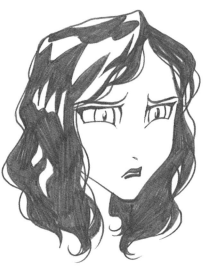

HURT

She bites her lower lip to fight back the tears; to do this, draw a full upper lip, with downturned ends, and omit the bottom lip altogether.

HURT

She has trouble dealing with real feelings, so she looks as confused as she does hurt. Give her worried eyebrows (upturned) and tight, puzzled lips.

EXTREMELY PLEASED

With an open, honest face, the good gal beams when pleased. Her eyes are as wide as they can be without rolling out of her head, and her mouth cocks to one side in a giant smile.

EXTREMELY PLEASED

When she's happy, it's due to the imminent misfortune of others, so give her evil eyebrows and an expectant smile, teeth showing.

GOOD GAL BAD GAL

SHOCKED

Both eyebrows rise in total shock. The mouth becomes quite elastic.

SHOCKED

Although they are raised, her eyebrows still point down. Her mouth is small as she tries to contain her emotions.

DISBELIEF

Determined eyebrows coupled with lips cocked to one side.

DISBELIEF

Cynicism and skepticism are natural states to her. If someone is lying, she can't help but smile a bit because it's a quality she admires!

DEFENSIVE

No doubt about this expression—she's ready to fight for what she believes in.

DEFENSIVE

She's deciding how she can manipulate the situation to her advantage, as evidenced by the pursed lips.

Hands

Just as facial expressions are important, so are hands, and hands are an area that often gets neglected. It stands out like a sore thumb, pardon the pun, when you have a great-looking character with amateurishly drawn hands. But, all that can be easily fixed. This section offers some pointers and examples of the most common hand poses.

Hands should, above all else, look natural, not deliberately posed. We move our hands without conscious thought, the way we move our legs when walking—it just happens. If you have to work too hard in your drawing to achieve a certain hand pose, then the pose might be unnatural and should be substituted with another one.

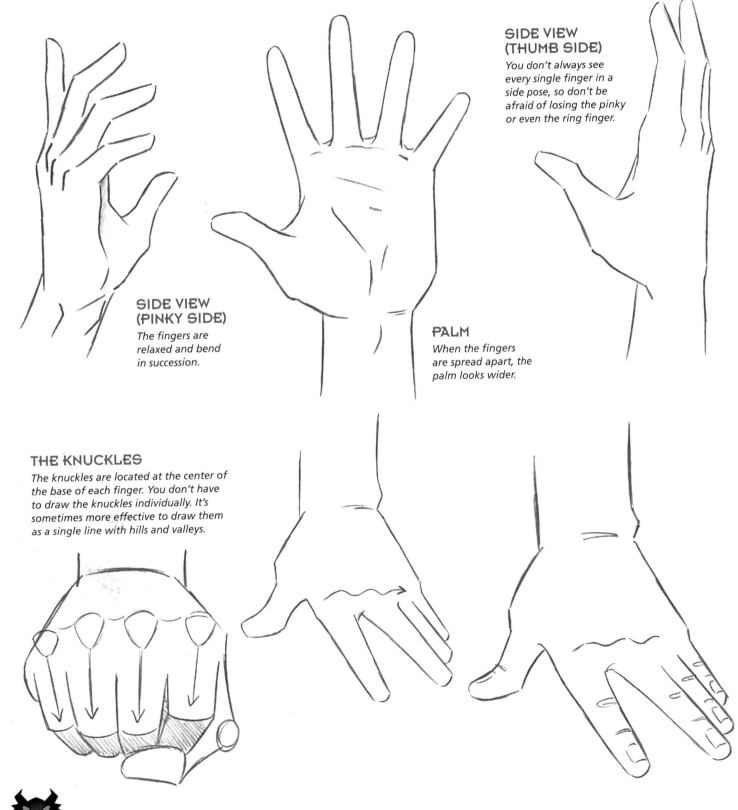

SIDE VIEW (THUMB SIDE)
You don't always see every single finger in a side pose, so don't be afraid of losing the pinky or even the ring finger.

SIDE VIEW (PINKY SIDE)
The fingers are relaxed and bend in succession.

PALM
When the fingers are spread apart, the palm looks wider.

THE KNUCKLES
The knuckles are located at the center of the base of each finger. You don't have to draw the knuckles individually. It's sometimes more effective to draw them as a single line with hills and valleys.

THE THUMB'S BIG KNUCKLE

The thumb has a large knuckle that's quite prominent when the fist is closed. Many aspiring artists leave this out and wonder why the fist looks wrong. Always indicate the big knuckle of the thumb, and you'll be well on your way to drawing dynamic fists.

BIG THUMB
KNUCKLE

BIG THUMB
KNUCKLE

BIG THUMB
KNUCKLE

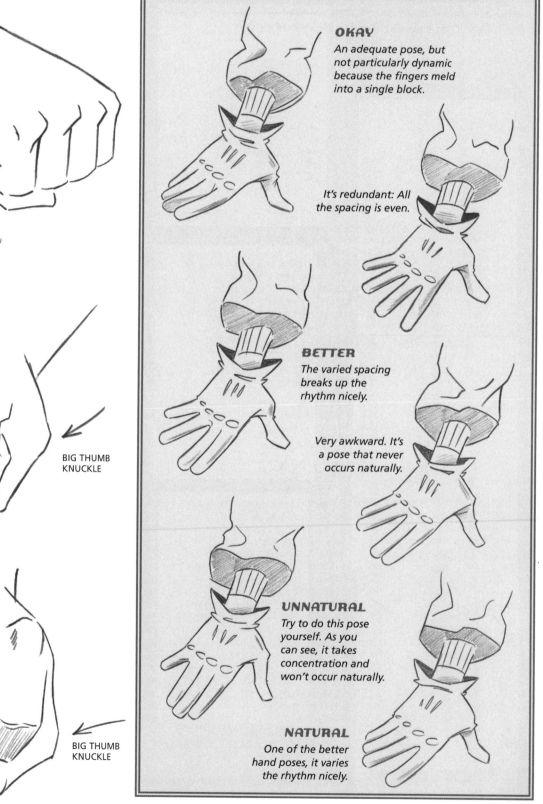

NATURAL VS. UNNATURAL FINGER PLACEMENT

Sometimes hands grasp things, sometimes they create fists, and sometimes they point. But invariably, you're going to draw many more characters with hands that are simply open and not "doing" anything in particular. At those times, you've got to pose the hands so that they look natural. So, which hand positions look natural and which don't?

OKAY
An adequate pose, but not particularly dynamic because the fingers meld into a single block.

It's redundant: All the spacing is even.

BETTER
The varied spacing breaks up the rhythm nicely.

Very awkward. It's a pose that never occurs naturally.

UNNATURAL
Try to do this pose yourself. As you can see, it takes concentration and won't occur naturally.

NATURAL
One of the better hand poses, it varies the rhythm nicely.

The Evil Guy Body

Professional artists usually begin by sketching the head, followed by the neck, then the torso, and then the limbs. The torso is the driving force behind the pose. Sketch the entire torso first before drawing the limbs.

Always draw the limbs in sections. For example, the upper arm is one section. The lower arm is another. Don't draw the limbs as long tubes with a bend in them at the joints. That makes them look like noodles.

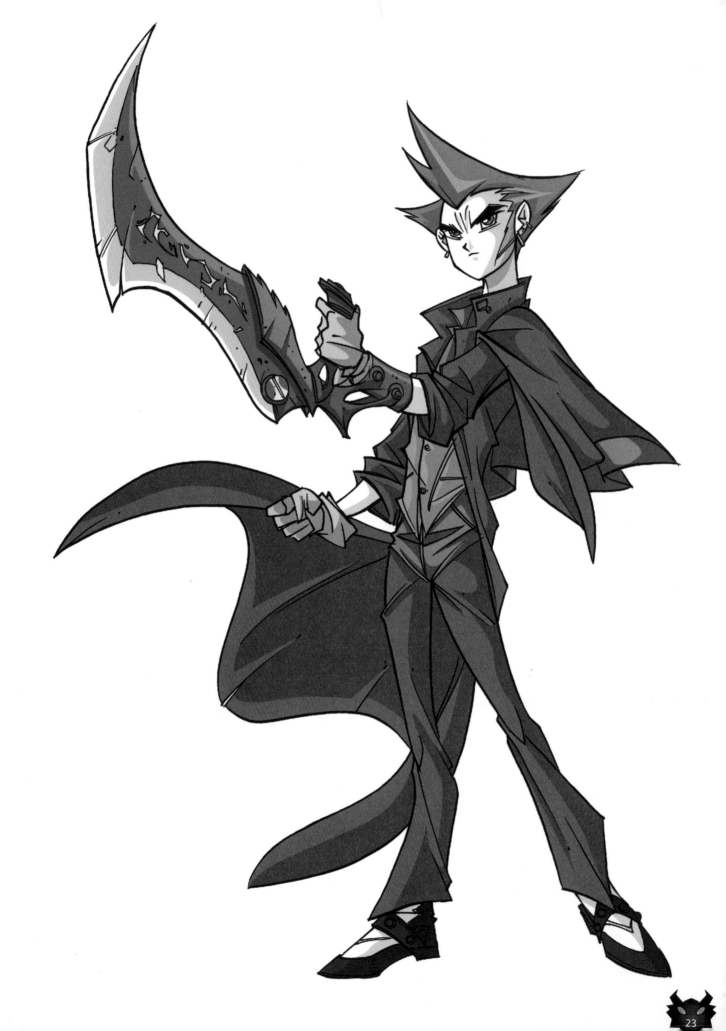

Evil Guy Body Types

The body is just as important in defining a character as the face. Think in terms of body types. If you're drawing a bully, his body has to be able to bully people. If you're drawing a wimp, his body must be wimpy.

The costume also plays a major role in a character's development. Manga characters communicate who they are with what they wear. You need to show your reader in an instant who the good guy is and who the bad guy is. Costumes do that for you. Let's explore some popular bad guy body types and costumes, and match them to their respective personalities.

BRUTE

Brutes, thugs, bullies, and jocks all share a similar body type. Their purpose in life is to steal your lunch money and your girl. Give this character a huge upper body and thin legs. Broaden his shoulders as far as you can, and give him big chest muscles. The muscles of his arms should be clearly defined, and the forearm bands add a sense of power to the arms. He wears a skintight shirt to make his bulk obvious. The boots are heavy-duty.

YOUNG REBEL

His posture has an I-dare-you quality to it. He's trim but not athletic. He's still physically immature—certainly not capable of taking on the big guys—but that doesn't stop him from mouthing off. His costume boasts all sorts of spikes and protective guards. His restless nature makes him an interesting character to watch.

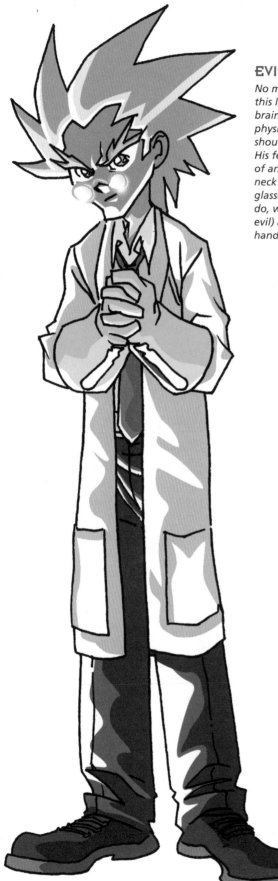

EVIL SCIENTIST

No muscles lurking beneath this lab coat. As a rule, the brainier they are, the less physical they are. This guy's shoulders are tiny and sloping. His feet are extra large—a sign of an unathletic type. Even his neck is scrawny. He wears thick glasses (most brainy characters do, whether they're good or evil) and lab gloves, for handling toxic chemicals.

KING OF COOL

Count your fingers after you shake this guy's hand. He's a totally dishonest, manipulative, scheming character. Note his slinky build and his posture, with his chin up in the air so that he's always looking down at you. He wears his clothes loose, for a calculated casual look. The tank top-and-jacket combo is meant to impress the ladies, who hate him for being a cheat but love him for his charisma. His sunglasses and watch probably cost more than his car.

The Evil Gal Body

She needs a very shapely body, athletic rather than heavily muscled. The jacket is oversized, which looks cool on a gal, but some of her clothes should also be formfitting to show off her great figure. Add the belts, buckles, zipper, clothing creases, and folds after you've established the basic pose. You'll know you've got her down when she looks like she works at a music store in Hollywood.

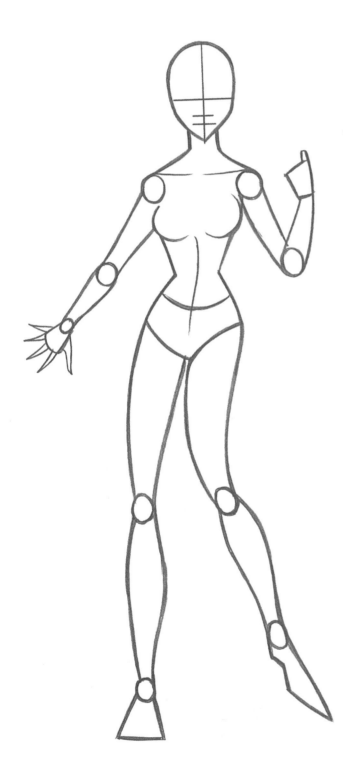

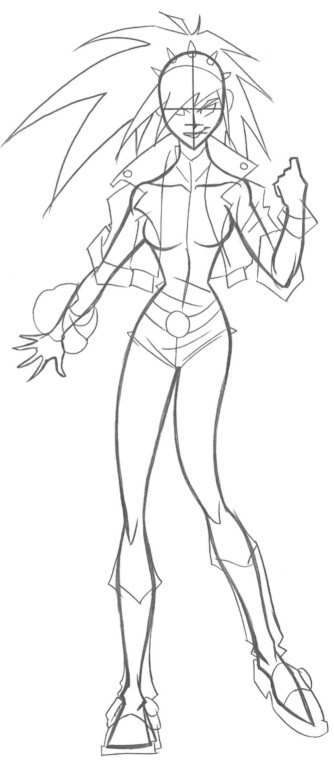

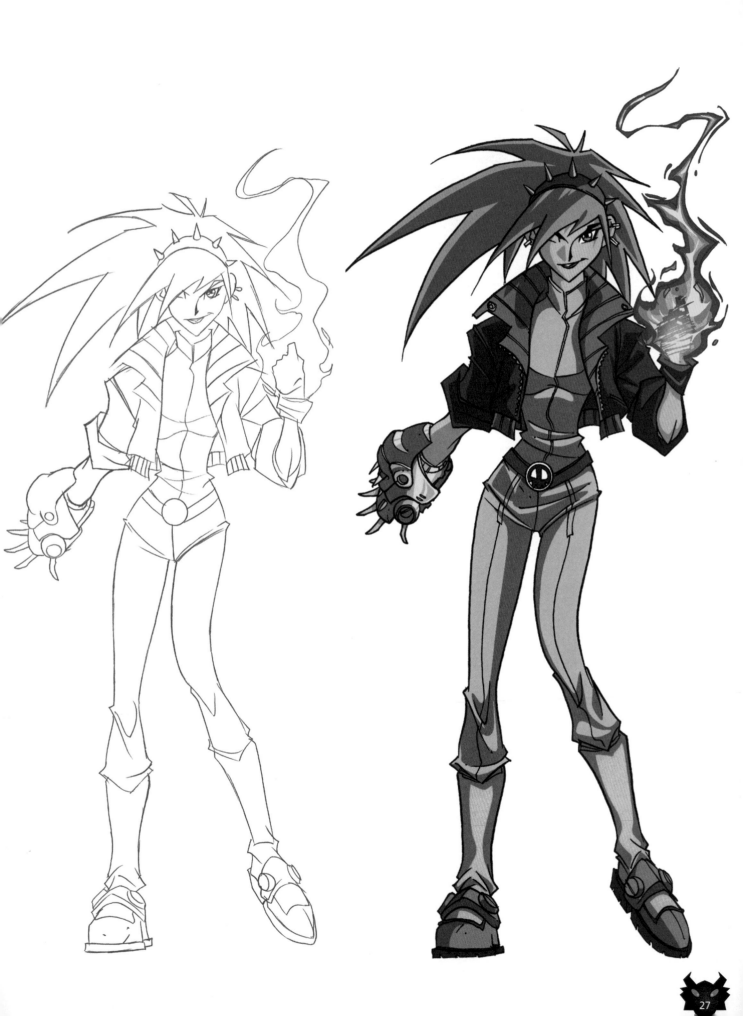

Evil Gal Body Types

On villainous gals, the body types are often similar. It's the costumes and hairstyles that make the difference.

SEXY MUTANT

Pointy ears, gothic wings, clawlike hands, and a figure that turns heads all add up to a great mutant character. She has a human body, but the details have been tweaked. She may look pretty, but she can reach into your chest, pull your heart out, and eat it. So, no, I don't think she'd be a good candidate for a serious relationship.

PUNK

With closed fists, she sports a fierce attitude that says back off. She's trashy/sexy, and very curvy with a thin waist and shapely legs. Her character is defined by her angry hairstyle and her antisocial clothing, which, all told, couldn't have cost more than eleven bucks.

FOREST WARRIOR

She'd as soon shoot an arrow into your knee as say hello. She's dressed in animal skins and carries primitive weapons, such as a long sword or a crossbow—and she knows how to use them. She's tough, resourceful, and athletic. The decorative headband signifies that she's a warrior in her society.

SCHOOL BRAT

Here is perhaps the most evil of all villains: the head of the school clique. On the one hand, she's pretty; on the other hand, she's pampered, spoiled, gossipy, back-stabbing, competitive, and extremely jealous. She's sweet and charming to her parents and her boyfriend, but a terror to the other girls in school. She wears a preppy school uniform. The wholesomeness of the uniform contrasts well with the nastiness of her personality. Her hair is always worn in exaggerated pigtails.

SHŌNEN MANGA

There are many popular types of manga, but one of the most popular in America and abroad is *shōnen,* which appeals primarily to teenage boys although it also attracts a significant female audience. Shōnen features action-packed, youthful characters—the type you'd see on popular animated TV shows or on trading cards. Lots of shōnen villains are teenage megalomaniacs. Sometimes they work in teams or with monster sidekicks, but wherever they go, they radiate wickedness.

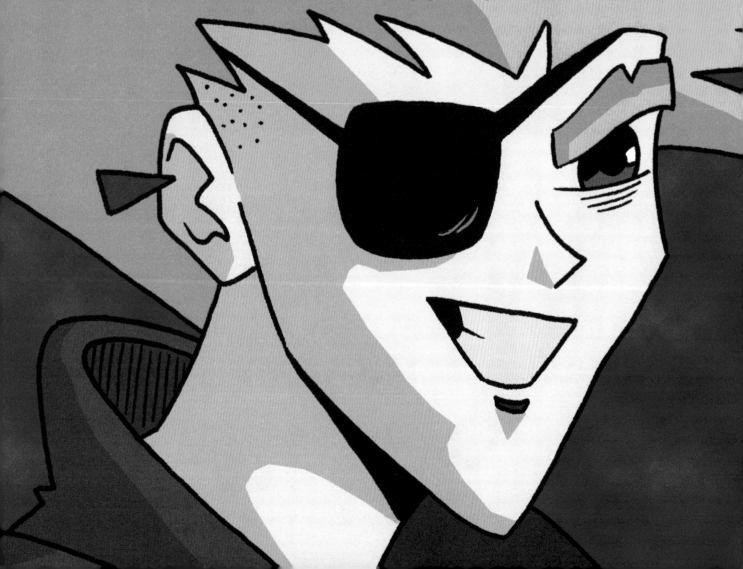

Smaller creatures have a great appeal to audiences and readers. They're evil but almost in a cute way, and they really liven up a scene. Try 'em out.

Team Villains

Villainous teams are very popular in shōnen-style manga. A team of villains wields more power than a solitary bad guy. In addition, a team of "meanies" mimics real-life situations in which bad kids form gangs and harass good kids. The characters in your bad guy teams should each play a different role. Variety is best. If your team has one muscle guy, he'll stand out as the one with the brute force. If your team is made up of three muscle guys, it gets repetitious. You also want to vary their special powers and abilities. Another thing to remember is that each team has its pecking order. There can only be one leader, one rebellious one, and one brainy one.

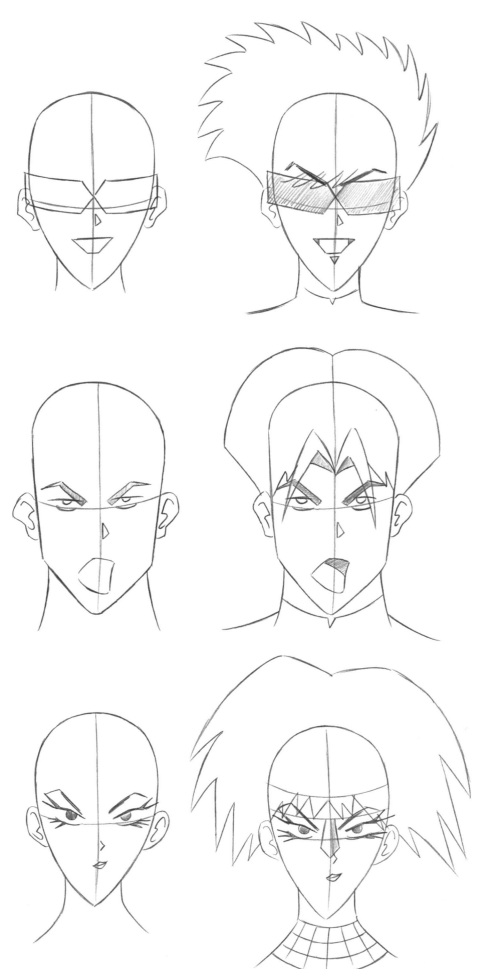

AN IMPORTANT NOTE ABOUT VILLAINS
This is a good time to make an important point about drawing villains in general. With some exceptions, you don't want to create evil characters that are so repulsive and ugly that your audience will be turned off. You can't maintain audience interest if the audience doesn't, on some level, like your bad guy.

The Archer

Take a knight, give him a bow and arrow, add spikes, studs, and a chain, throw a big scar across the middle of his face, slick back his long hair, and you've got one mean dude. Note the intense scowl and beady eyes. Good characters never have beady eyes. This is the type of character who would kidnap a princess, imprison her in a tower, and hold her for ransom.

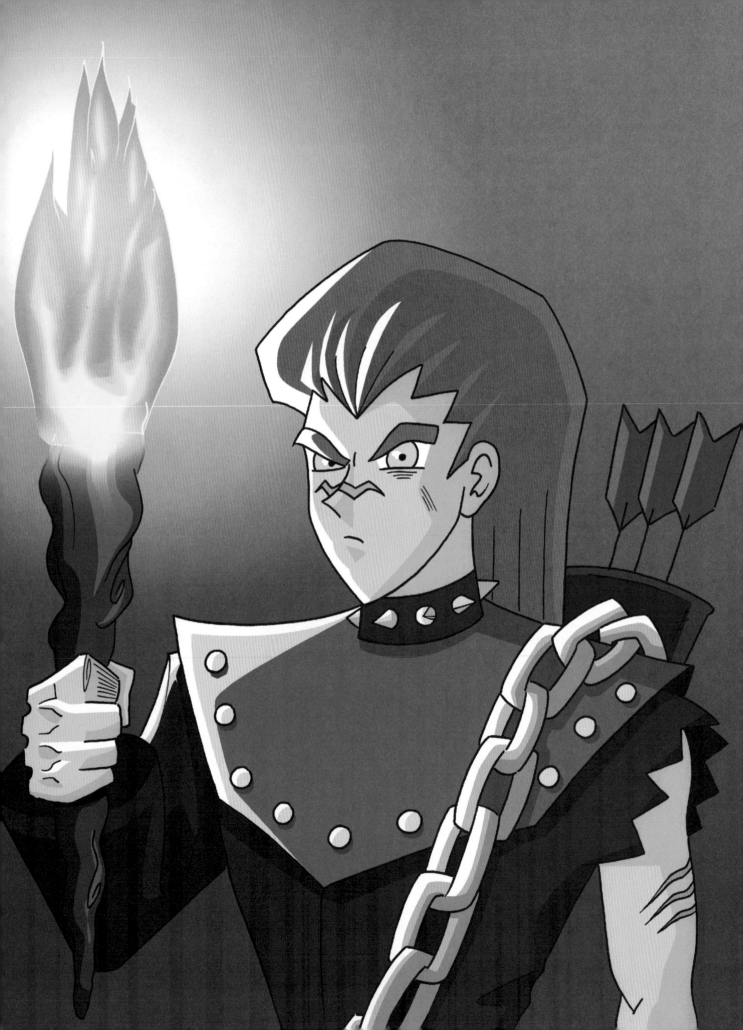

Fighter Chick

This type of character is extremely popular because she's always in the middle of the action. She has reckless hair, a lean figure, and tattered clothing, which usually includes some military fatigues. Whether she fights with weapons or in hand-to-hand combat, she always maintains a take-no-prisoners attitude.

The wide shoulders are a sign of strength. The arm tattoo and fatigues tell us she's a hardcore warrior. Since she's lean and athletic, it's especially important that you first sketch her figure before drawing the clothing. This enables you to shape the clothes to the contours of her body. This is very apparent on her tank top here, but the same principle is also at work on her big, roomy pants. By sketching the legs first, you can get those fatigues to look appropriately oversized, instead of making her look fat.

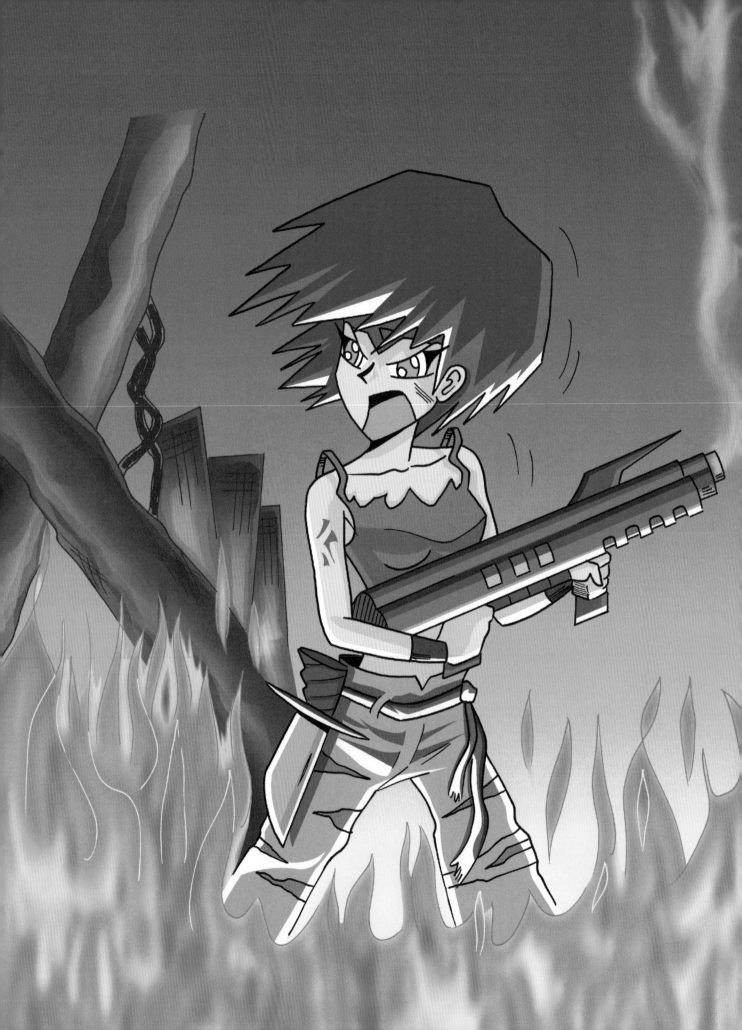

Getaway Driver

Getaway drivers love danger. This guy lives on the wrong side of the law—the wild side of it. He's a cool customer, out for nobody but himself. He has a great shock of hair, which has got to be shown blowing in the wind when he drives. Give him a devilish sparkle in his eye by drawing a big shine overlapping the pupils. He wears double scars over his eyebrow like a badge of honor. A leather jacket and racing gloves complete the look.

This guy never gets a ticket because no cop can ever catch him! In a typical anime show, the daredevil will drive up fast for a head shot, like this one, and then drive off in a flash, leaving nothing but a trail of smoke, broken hearts, and chaos in his wake.

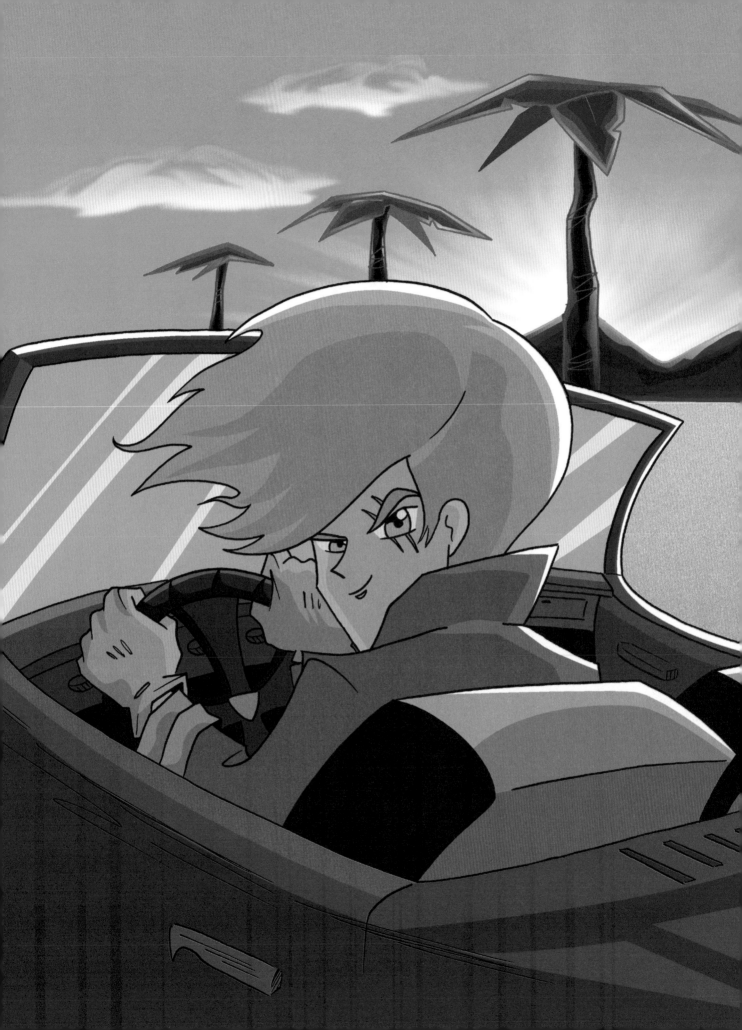

A Bad Guy and His Pets

Some bad guys have the ability to control the minds of small, evil helpers to get them to do their bidding. Characters with extraordinary mental gifts should have their special status indicated by mysterious markings. The markings could be on the face, arms, hair, or clothing. Of equal importance is the evil smile, which really communicates villainy. An evil smile is simply a smile combined with a frown and deep-set eyes. *Note:* And please, don't feed the monsters; they're on a very restricted diet—they only eat tofu . . . stuffed with human brains!

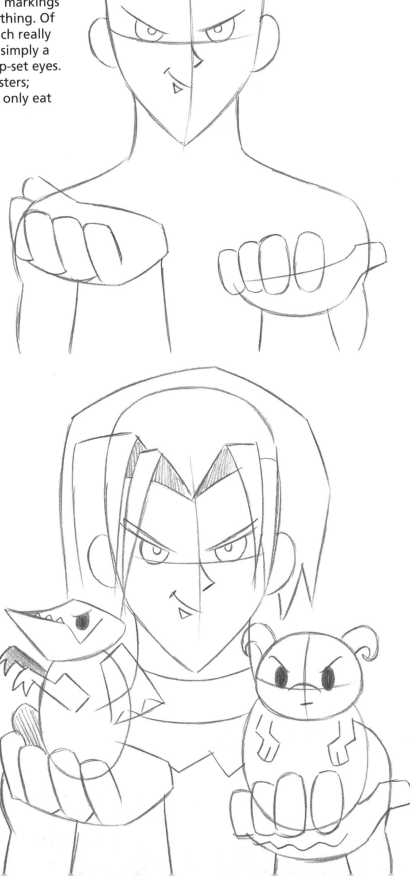

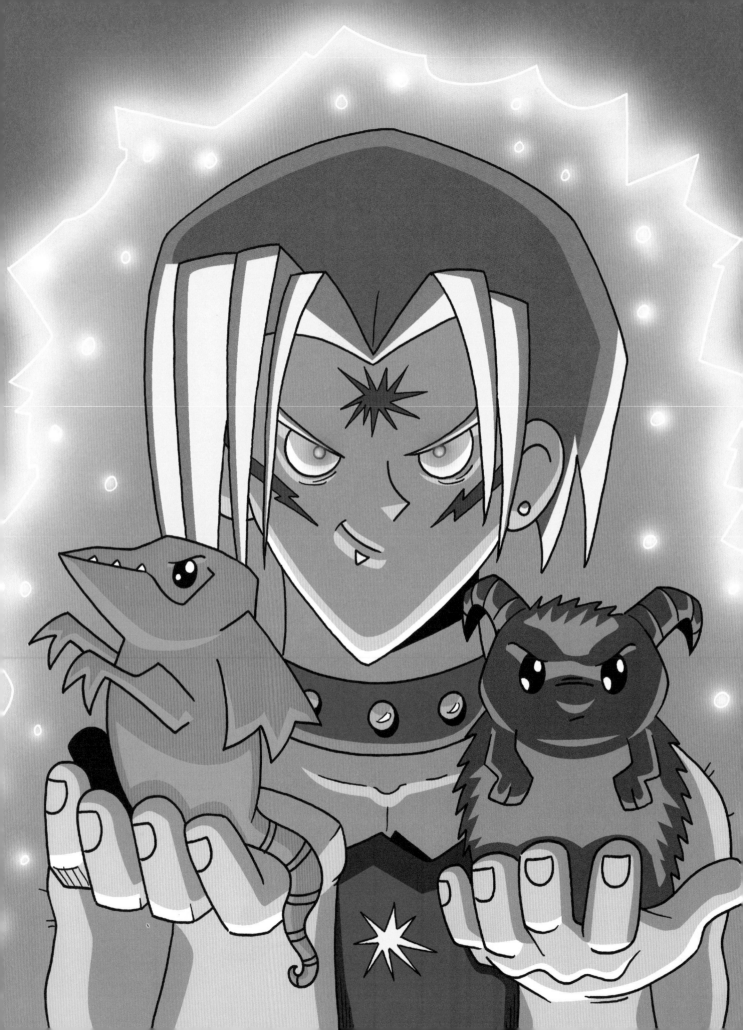

The Weird and Bizarre

Not every evil character has to be dangerous looking to be whacko. Sometimes characters are evil if they are bizarre enough. This doesn't necessarily mean drawing an angry-looking character. An alternative is to go retro. Take a squeaky clean, wholesome character from the 1950s, such as this diner waitress. Then twist the scene so that everything appears normal, except for one really wacked out thing. It's like walking into a darkly funny nightmare. This way you can get a laugh with your bad guy or gal characters. Your readers will enjoy the change of pace.

Female manga characters often have extremely long, thin legs. Notice that even though the legs are thin, they're still well shaped and not drawn as straight lines.

Punks with an Attitude

You've got to watch where you walk late at night. The streets in Mangaville are filled with punks like this. They make great villains because they're always looking for trouble—and they usually find it or create it themselves.

The punk's hair is often spiked. Sometimes, the side of his head is shaved to stubble. Earrings are a must. The eye patch is a nice addition, although you could use a cyborg eye implant or ear attachment instead, if you prefer. The shirtless vest is a trademark of manga villains.

BEYOND SHŌNEN

Now we move on to a slightly older audience, for which the characters are just as colorful but more dangerous. The creatures are more menacing and the women are sexier. Older teens and adults want characters with more of an edge to them. Therefore, the faces and bodies of these manga bad guys are not as round as they are on the younger characters. The eyes, although still manga*esque*, are not quite as big. The bodies are sturdier and more mature. With characters who are always in the middle of the action, this style of manga rocks.

Teen Villains

The typical shōnen-style characters are young teens. Their monster sidekicks are big-eyed and cute. As you move up the food chain to the types of characters that are popular among older teens, the bad guys are usually young adults, and their sidekicks are much more severe, often human-animal hybrids.

Maniac Gladiator

This extreme character is a typical marauder, hell-bent on destruction. He's a soldier in an army of one, an enforcer of order in a lawless land. Give him a thick neck and superwide shoulders. As with all big tough guys, draw the head small in order to make the body appear, by contrast, that much more impressive. The chest muscles should cut a wide swath across the entire torso. Note the ready-to-fight stance. The spikes are essential to identify his role as a walking weapon. On bad guys, you can exaggerate the eyebrows to an incredible degree, even beyond the head.

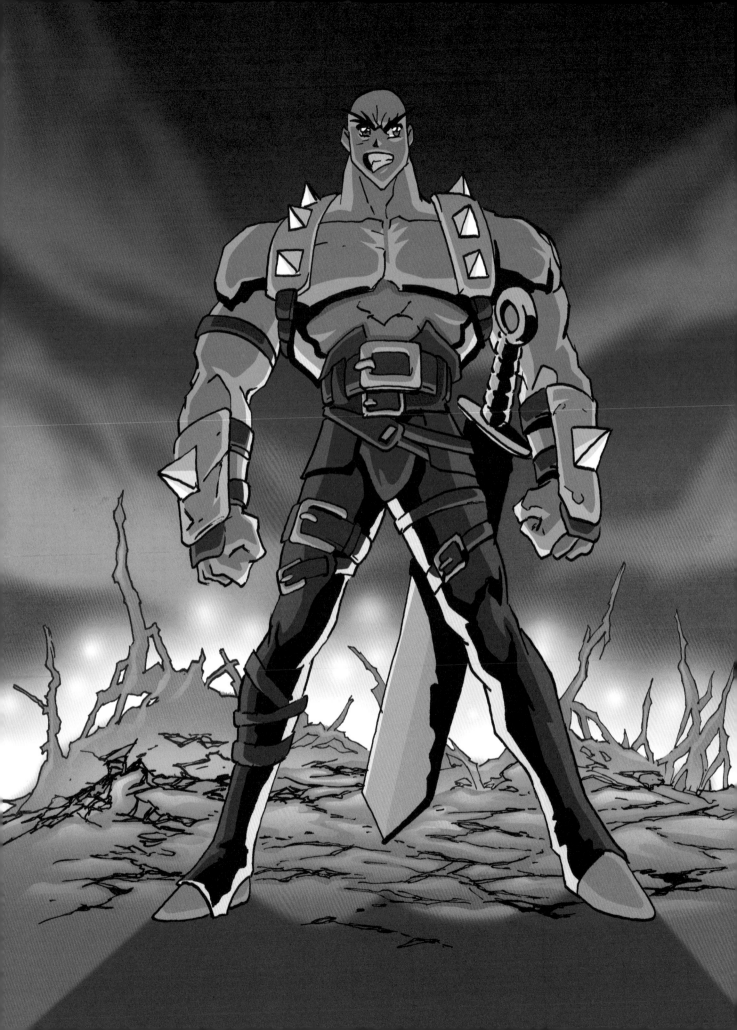

Winged Destroyer

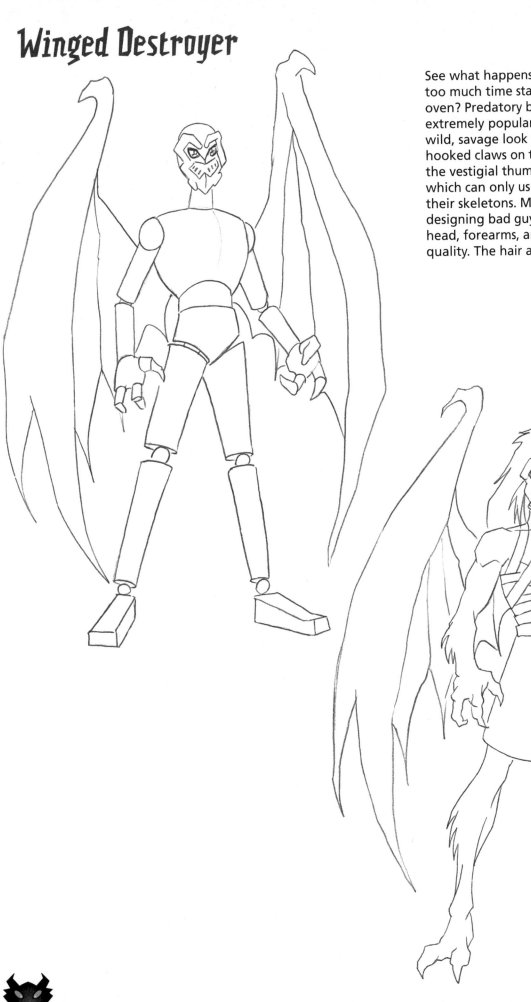

See what happens to you when you spend too much time staring at the microwave oven? Predatory bird/human hybrids are extremely popular, especially if they have a wild, savage look to them like this guy. The hooked claws on the top of the wings are the vestigial thumbs that all birds have but which can only usually be seen by examining their skeletons. Make them stick out when designing bad guys. The ruffles of fur on the head, forearms, and calves give him a feral quality. The hair almost becomes a mane.

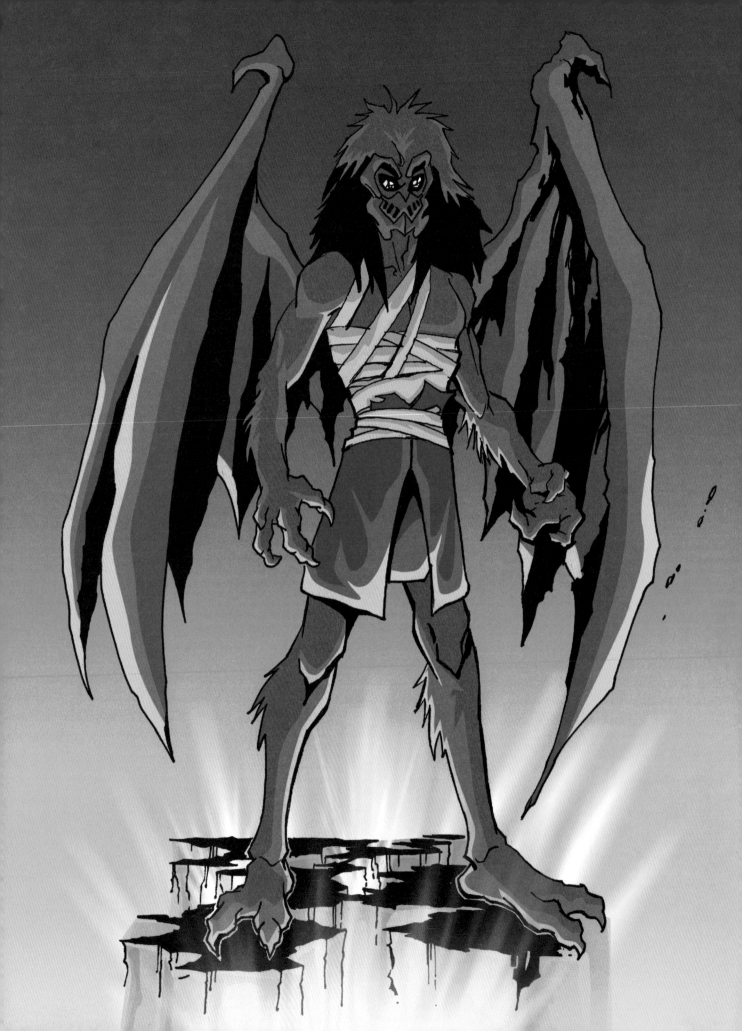

Avenging Sorceress

If she's evil, how come all the guys want to date her? With her hair trailing off in a flamelike shape, and her outfit both exotic and hypnotic, this character is ready to entice and then destroy. She carries with her a magic staff, which has irresistible powers. This is a good example of a character whose special effects are not an afterthought but a part of her design. Wherever she goes, she emits a radiant, dark magic.

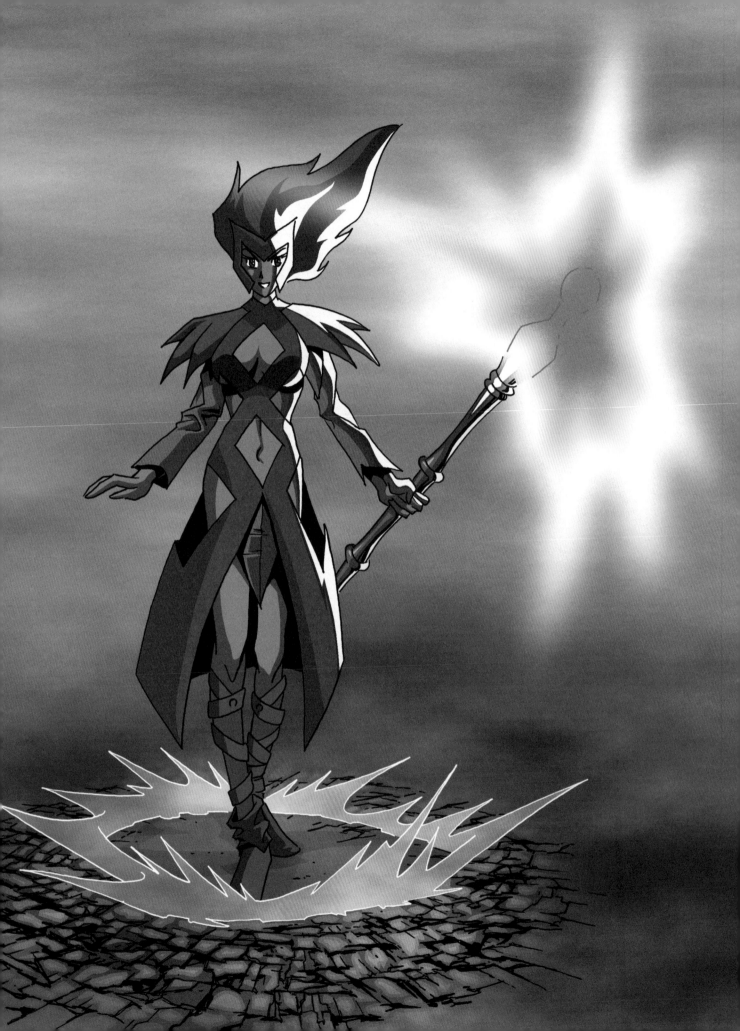

Bubble Gum Warrior

You can't draw teenage characters without tossing in a mall rat once in a while. This gal is, like, totally awesome! She'll beat the tar out of anyone who stands in her way and then go shopping with daddy's credit card. She has incredible strength and fighting skills, and she's not averse to using them. She is selfish, immature, and jealous. And someone's going to pay if she's in a bad mood! Give her pigtails, capri pants, and a tough-as-nails attitude. Draw her body athletic and flexible—attributes she uses to perform her martial arts and acrobatic moves against multiple opponents.

This pose shows a lot of good body action. Notice that her left shoulder dips down while her hip on her left side tilts up, creating tension in the body. This results in a nice stretch on the opposite side of the body.

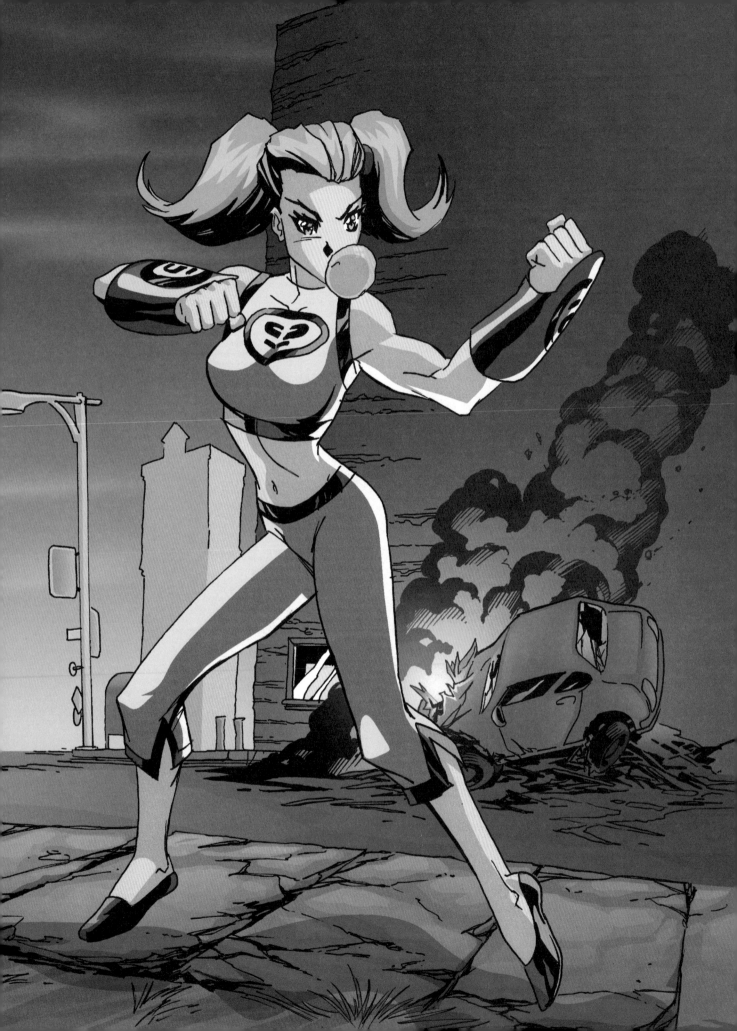

The Seductress

The only thing sincere about the seductress is her love of money. She's a great character because she can find the weak spot in an otherwise sturdy hero. Her clothes are suggestive, but more than that, she knows how to use body language for maximum effect. As her legs cross, the skirt rises up, and one leg dangles on top of the other, toes pointing to elongate the look of the leg.

 Your seductive character should look as if she has cornered the market on mascara and eyeliner. Her lips should be quite full, with a shine for glossy lipstick. And her hair should fall forward casually over her forehead and shoulder. Pointed fingertips suggest long nails.

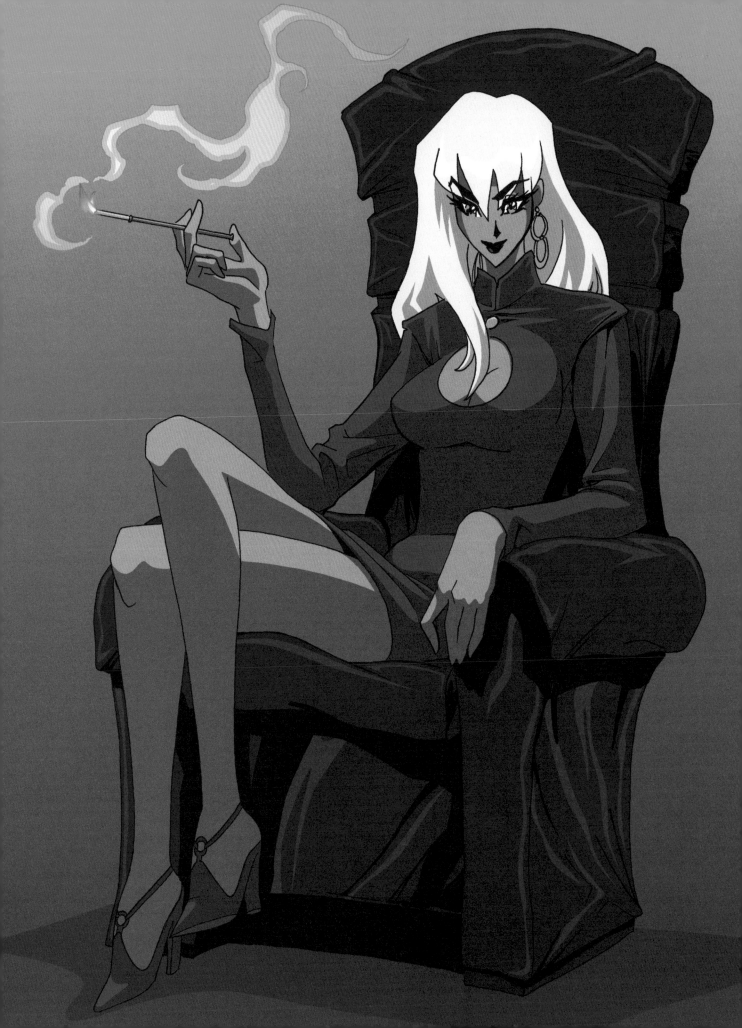

Cyberhacker

In the future, hackers are the most wanted outlaws on the planet. In a world controlled by the thought police, they have access to unlimited communications and knowledge. Always on the run, they've got to travel light, with highly mobile equipment. Hackers can't spend too much time in any one place or government officials could pinpoint their location. Since this guy's a counterculture character, give him an antisocial haircut. You can't work for a corporation with hair like that!

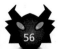

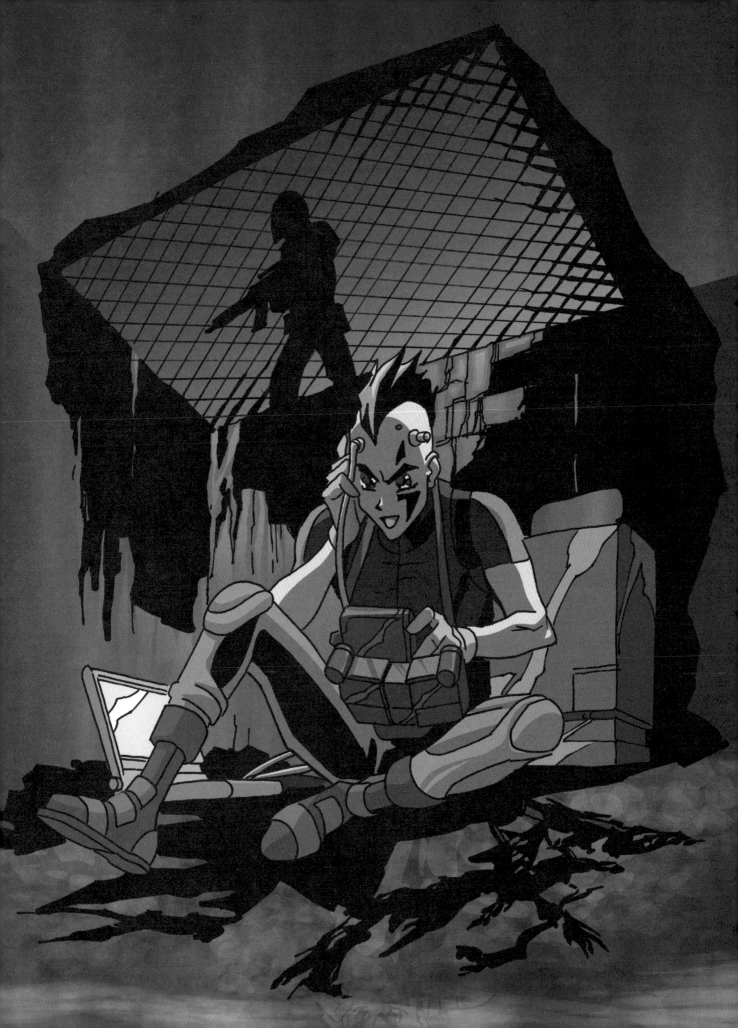

Shiver Me Timbers!

You can take any period from history and find cool villains to use for your manga adventures. The past is filled with flamboyant characters from eras when costumes were king. With a few modifications to a standard pirate—such as the fantasy sword, hooked arm (rather than a hook attachment), and manga-style eye—a new bad guy is created.

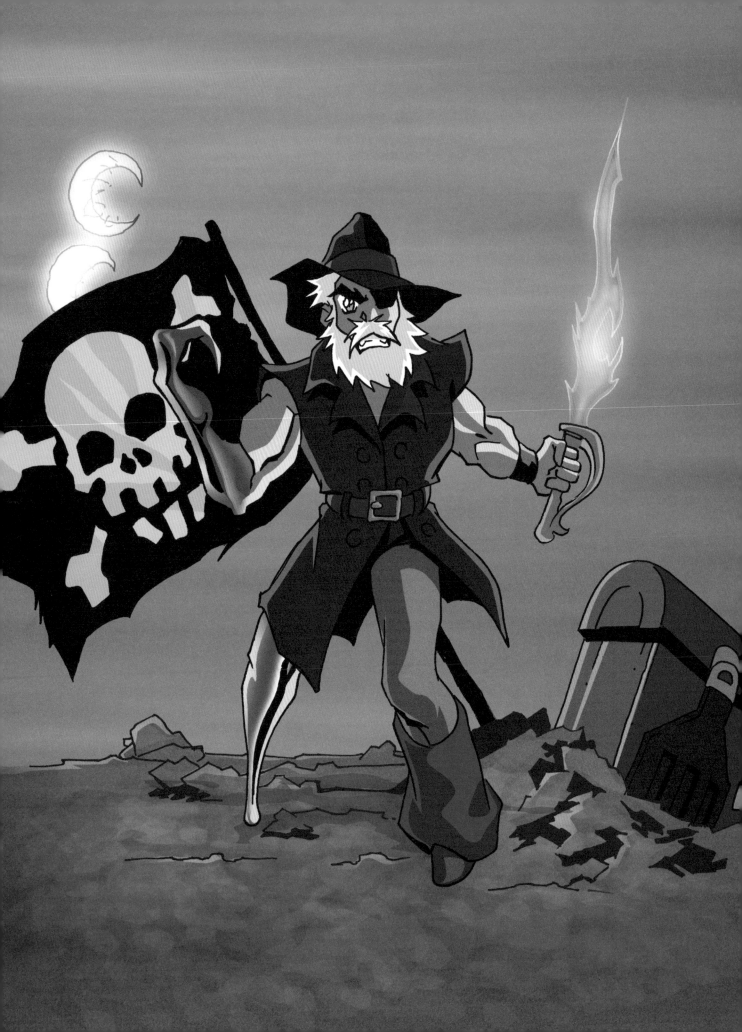

Alien Woman

You don't need to give your character five eyes to prove she's from outer space. In fact, the most popular aliens very closely resemble humans. Maintaining a predominantly human form has several advantages: First, a creature drawn as a woman, for example, can be attractive to readers, which wouldn't be the case if she had tentacles growing out of her forehead (unless you're into that). Second, readers can identify with her because she looks like them. Third, if she has the ability to retract her alien spikes and claws, she can pass herself off as human, which is a great chameleonlike ability. And fourth, because of how she looks, we assume—and can believe—that she speaks English and can interact with humans, whereas if she looked like a sponge with fangs, that would be more of a stretch.

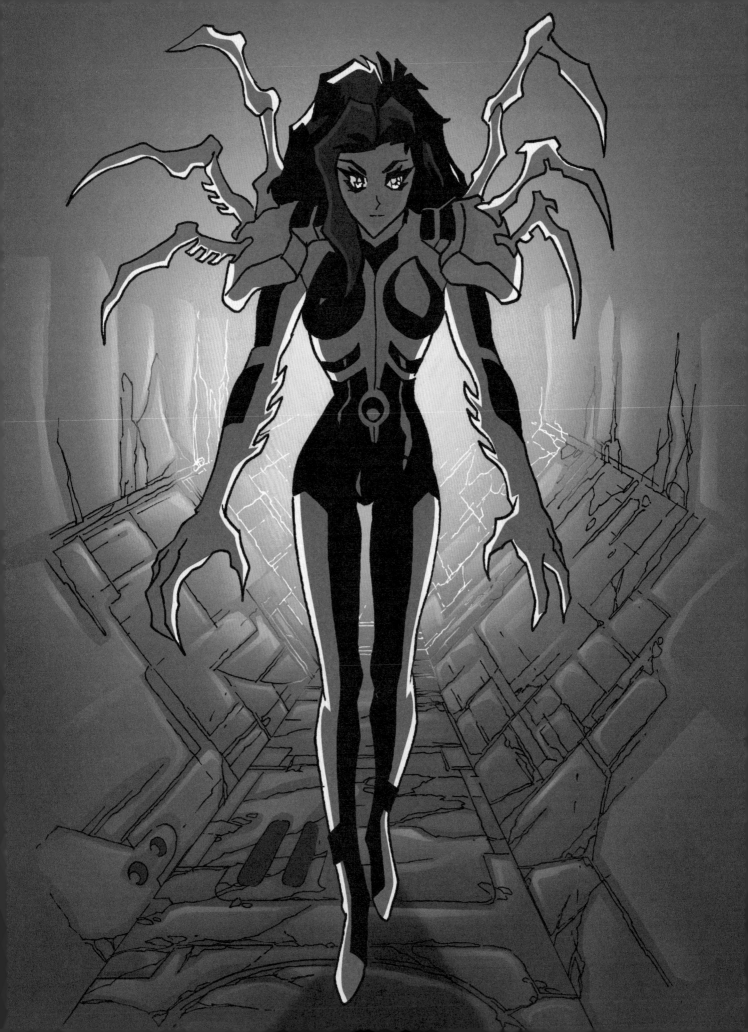

THE MONSTERS OF MANGA

Drawing monsters is great fun, because you're not constrained by what they *should* look like. Heck, they're monsters! Draw and color them any way you like! Be extra bold with the colors. (It's a scientific fact that monsters come in a wide variety of hues.)

The little monsters of manga are some of the best-loved characters of Japanese comics and anime. And no wonder. They're cute, even though they're mischievous and bad. The big monsters of manga are more treacherous and powerful. When they enter a scene, there will be a battle. You can count on it. Typically, these monsters are extremely tall and can fling a human hundreds of yards with a flick of the wrist or a snap of the tail.

The Little Toughie

He's short, but he doesn't know it. This little guy has tremendous strength, far beyond even the strongest human. Like many tough-guy characters, he has a small forehead with huge eyebrows set on a prominent brow, reminiscent of the brow of a gorilla. (On humans it's called the supraorbital arch and eminence, for you anatomists.) Also typical of tough-guy characters are massive jaws and no necks. Give him a bigger upper body (for strength) and tiny legs, which have the effect of exaggerating, by contrast, the size of his torso.

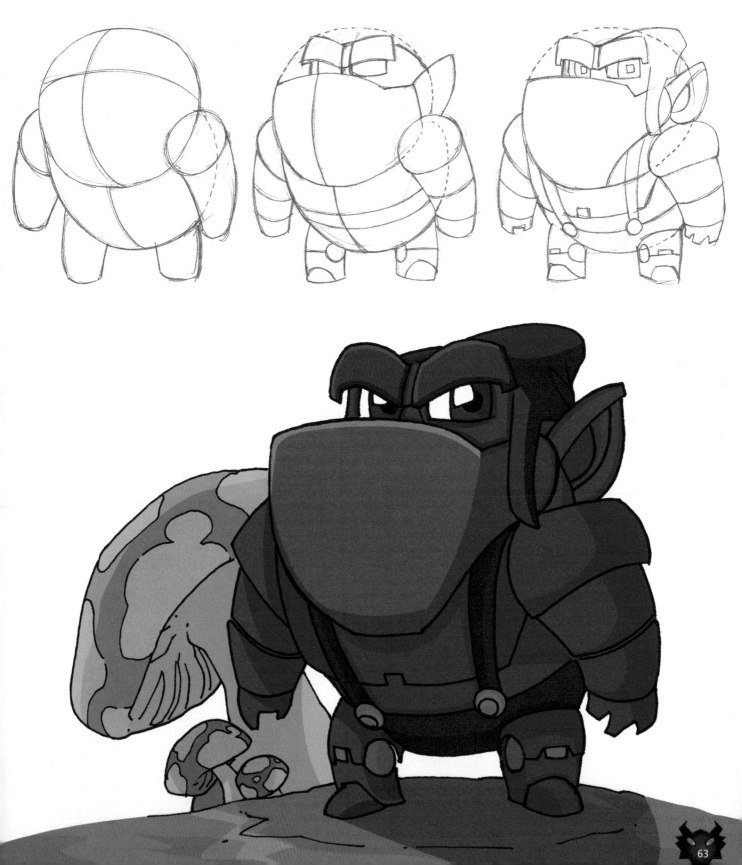

Insect Thing

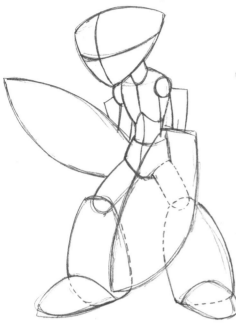

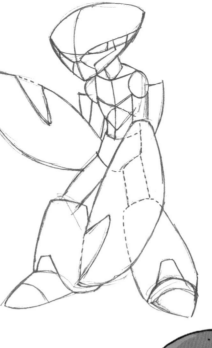

As if insects weren't gross enough to begin with, manga artists have brought them to a whole new level. However, to avoid making insect-inspired characters appear too buglike, soften the look by combining the insect with a crustacean, such as a crab. Since the most recognizable features of a crab are the claws, exaggerate those. This little fellow stands like a human, and in fact, you can see by the early steps that the anatomy is not so different from that of a boy with big boots and forearm shields.

Animal Combo

The hippopotamus is a fat and grumpy mammal but it's oddly endearing, especially the baby hippo. The lion is ferocious. By combining the body of one with the mane of the other, you create a cute yet angry character—the perfect little manga monster.

What powers should you give this little creature? Since his appearance is semicomical, his powers should be, too. How about the ability to roar so loudly that it creates a hurricane? Or, perhaps, a bouncing talent that lets it bounce up high and land on its enemy, flattening him or her like a pancake?

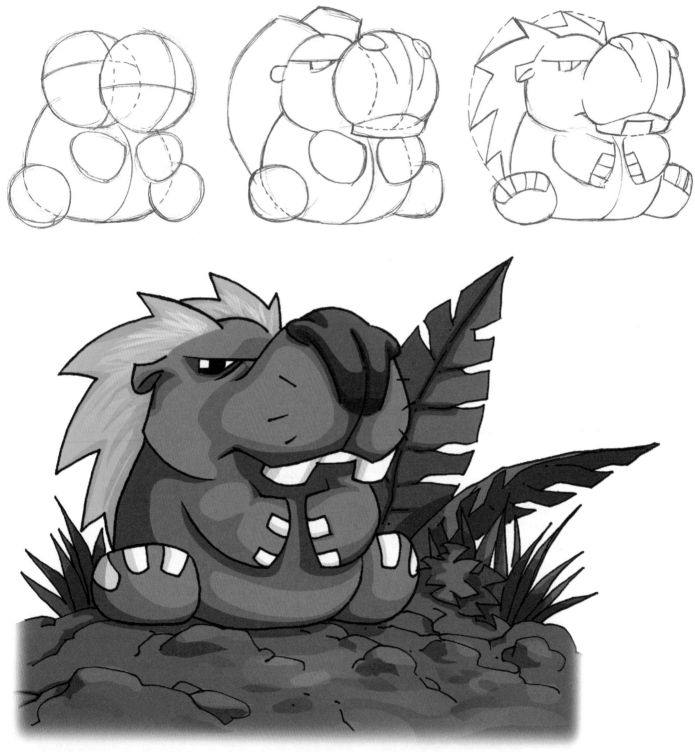

Plant-Based Monsters

If you want a really weird effect, try creating monsters out of plants. Start with human body structure, then add stalks and shoots sprouting from all over. There are many types of plants and plant-related items that would make good monster material: cacti, thorns, ivy, Venus's-flytrap, branches, seaweed, and more.

Coming up with names for your monsters is fun—and important, too! A good name is one that's memorable, locking in the identity of your character; this builds reader loyalty and, eventually, a following. As is often the case with the little monsters of manga, the name is derived from a word that has to do with the monster's ability, role, or appearance. The name must also sound fun or at least mysterious. For example, a few good names for this portly but baby-faced bad guy would be Devillion (derived from *devil*), Fatseeno (derived from *fatso*), and Masteekar (derived from *master*).

Chubby Critters

When you see one of these types of monsters, you don't know whether you should run away or hug it. Chubby little monsters are squeezable but still evil, and they're quite popular in anime and manga.

EVIL AND FUZZY

Overlapping is a great technique to use when you want your drawings to read clearly. Here, the arm overlaps the head, the head overlaps the body, the line of the tummy overlaps the thigh, and the jagged line of the back overlaps the tail.

IMPLANTS

Whether they're mechanical devices or something as simple as three ornaments on the forehead, implants transform an animal into a monster creature. Of course, the anatomy of this owl has been changed considerably. Still, if those implants were removed, it would look like just a funny owl rather than a little manga monster.

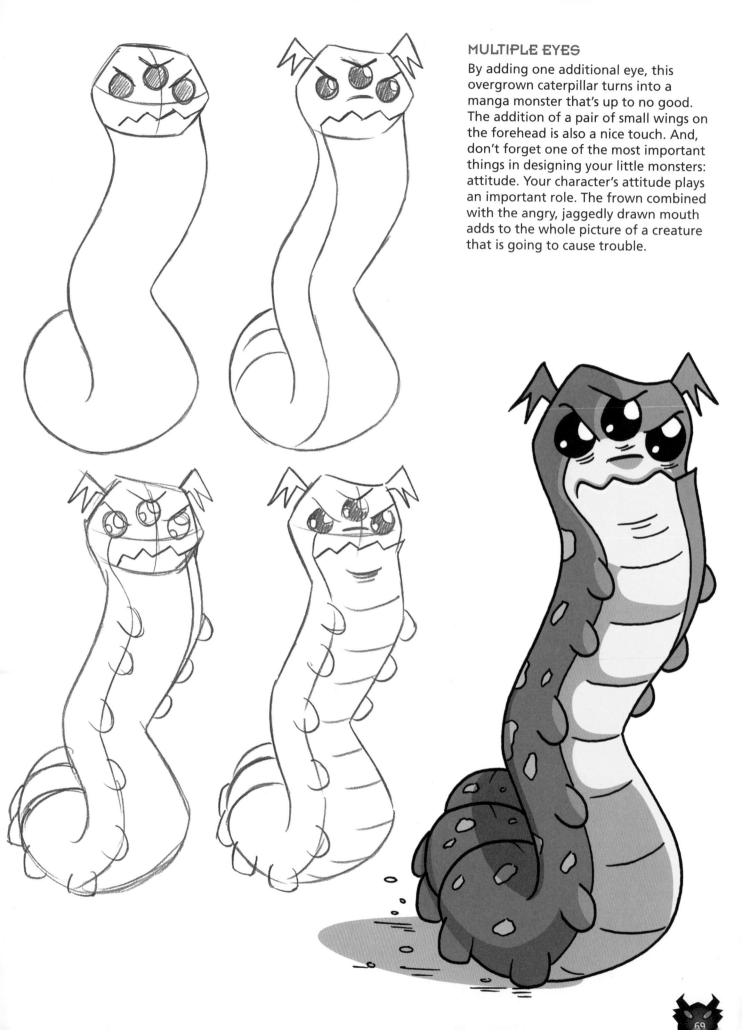

MULTIPLE EYES

By adding one additional eye, this overgrown caterpillar turns into a manga monster that's up to no good. The addition of a pair of small wings on the forehead is also a nice touch. And, don't forget one of the most important things in designing your little monsters: attitude. Your character's attitude plays an important role. The frown combined with the angry, jaggedly drawn mouth adds to the whole picture of a creature that is going to cause trouble.

Human-Animal Combos

For the big monsters of manga, some of the most hideous and effective characters are vicious animals that have human bodies. Let's examine what makes them work.

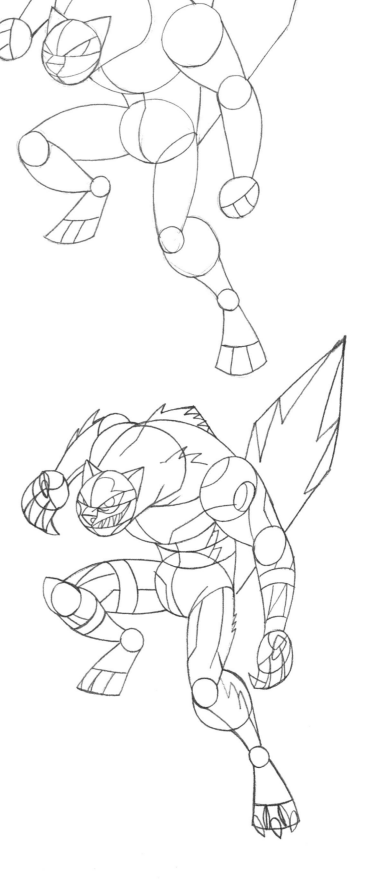

GIANT MAN/WOLF

With the head of a ferocious animal and the body of a man, the savage animal mind is in control, which makes this a more frightening opponent than a creature with the head of a man and the body of an animal.

Drawing the body long limbed and lanky gives the impression of great height. Then, adding tremendous width and size to the shoulders increases the effect. Finally, elongating the arms creates the image of a true giant.

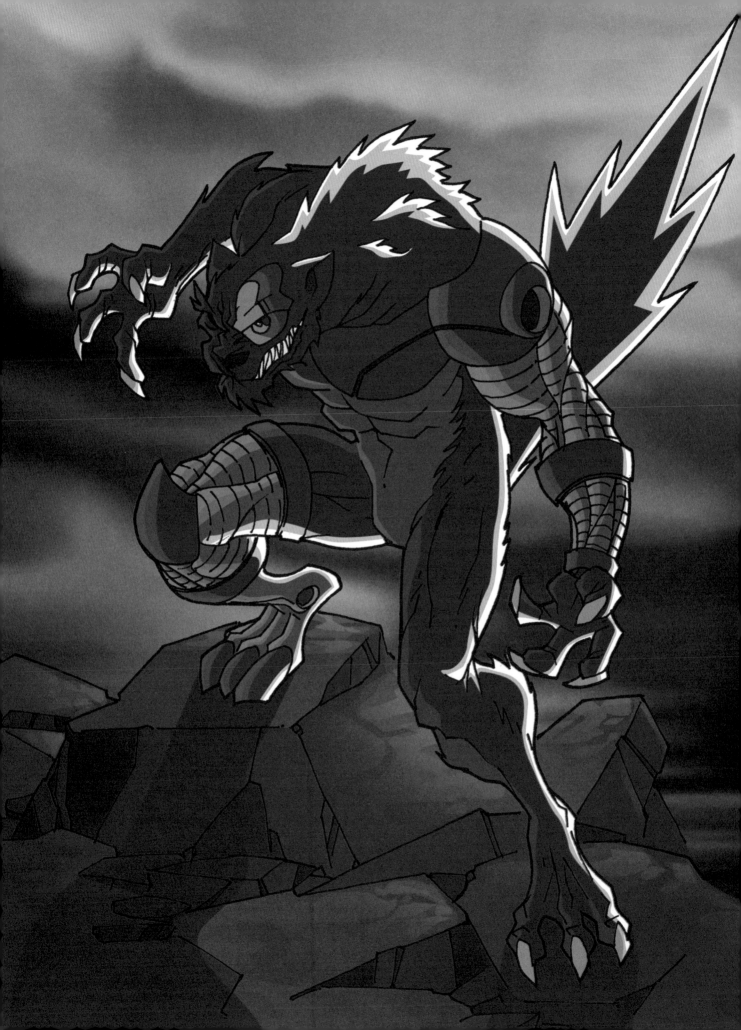

MAN/REPTILE

Reptiles are like money in the bank.
Everyone finds them strangely fascinating
and repulsive. So, when you need a bad-guy
creature, you know where to go. Nowadays,
audiences have become more sophisticated,
so a big iguana just won't cut it anymore.
You need to transform your reptile into a
monstrous beast. Combining a lizard with
a man's frame will do the trick, but make
sure the physique is bulked up. Then,
add colorful markings.

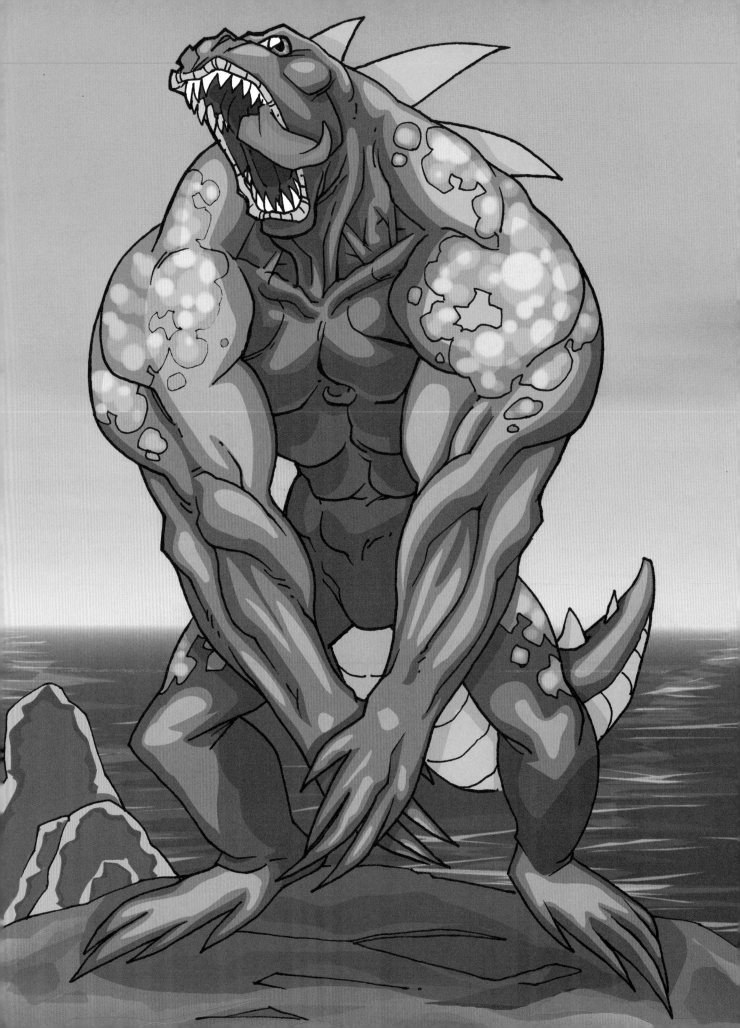

MAN/BAT

Once again, a real animal—the bat—is transformed into an exotic hybrid. It has a human torso and upper legs while retaining the head of the original animal. Note how the "fingers" fan out across the wings. This gives the wings a foundation; without them, they would just billow in the wind like a cape. In order to give the creature the appearance of power, a hunched back was also adopted.

Mythical Animals

Mythical beasts always make good inspiration for villains because they're mysterious and powerful. The griffin—with the head, forepart, and wings of an eagle and the body, legs, and tail of a lion—is, perhaps, the most popular of all. Others include the harpy (part woman, part bird), Hydra (a multiheaded serpent or monster), and the gargoyle (an ornate, grotesque human or animal figure, usually carved as a statue to guard the entrance of a castle or other building).

However, you don't have to confine yourself to the myth. You can custom-make your creature. Your griffin could have two heads or the tail of a dragon. The more unique you make it, the more it becomes your own invention.

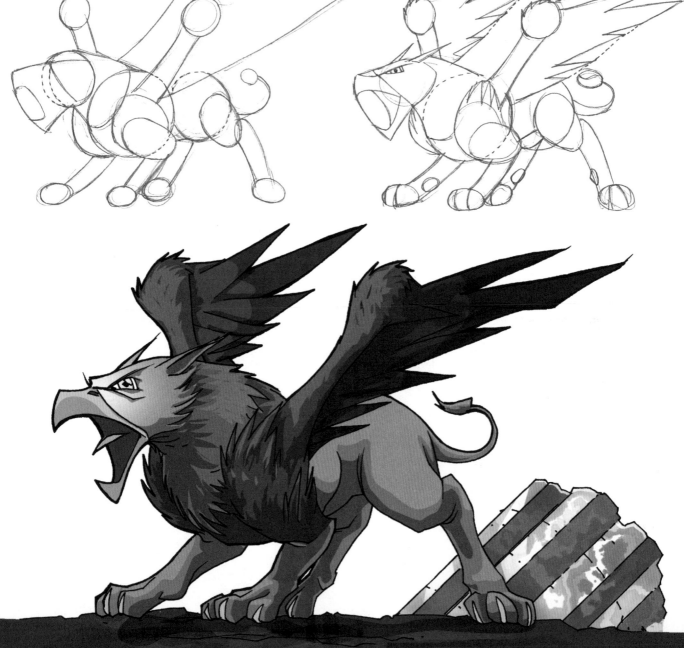

T-Wrecks

Dino-guy is in a very bad mood. Can you blame him? How'd you like to wake up each morning to that face in the mirror? Dinosaurs are reliable bad guys because we associate them with brute power and size, not to mention a predatory nature. And take a look at that mouth! Predatory mammals, such as lions, have two fangs, but the dinosaur has a face full of razor-sharp teeth. Don't be constrained by trying to draw a literal dinosaur. You can create variations on the dinosaur theme by adding large plates on the back (like those on a stegosaurus), two tails, a pair of wings (like those of a pterodactyl), horns on the head, and so on.

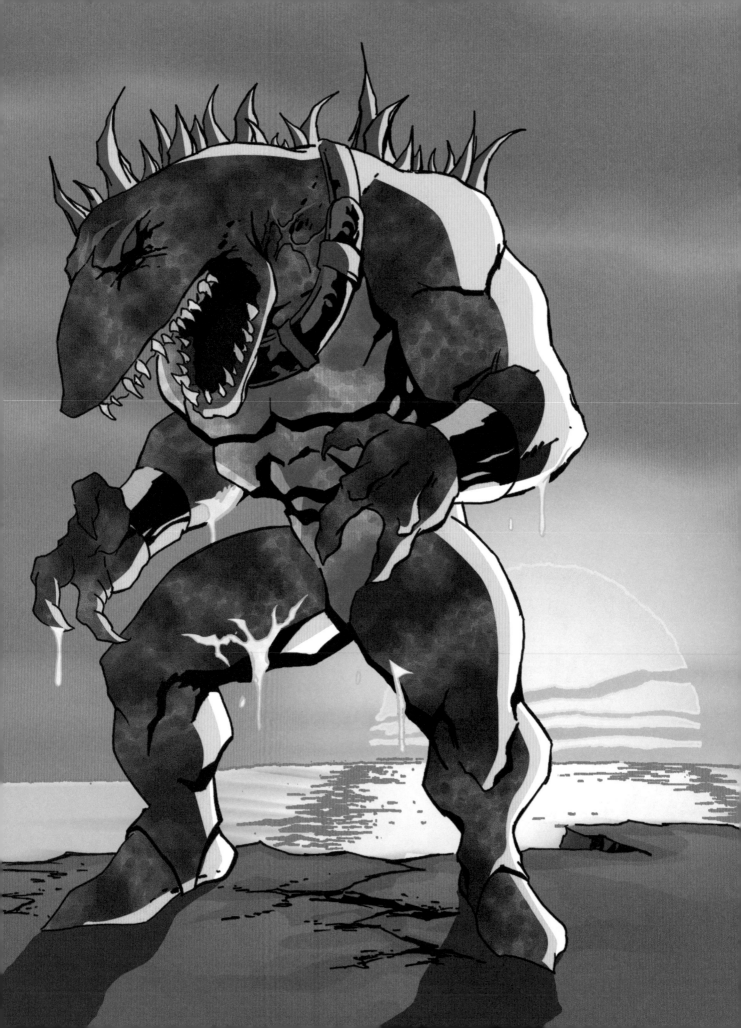

GLAM VILLAINS

These guys and gals are the rock stars of manga. Whether they're jewel thieves or wicked goddesses, evil knights or elegant princes, they all have extra helpings of charisma. They're all lawbreakers posing as heartbreakers. They're cool under fire, elegant, smart, and sometimes even refined. They're the bad guys you *root for* and then wonder why. It's because you've been charmed, just like all of their victims. These guys and gals are very popular in manga.

Glamorous Occult Figures

There are no witches with bent noses and chin hairs in manga. These witches are wicked *beauties*. Witches gain their powers by combining secret ingredients that, when stirred, can manipulate both man and nature. There are several stereotypical trademarks of the witch that will immediately identify the character for the reader. The first is the brewing kettle; the second is the pentagram.

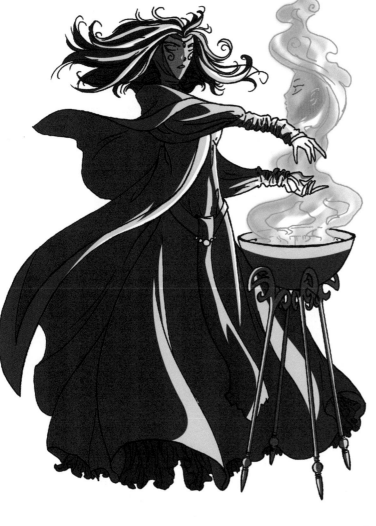

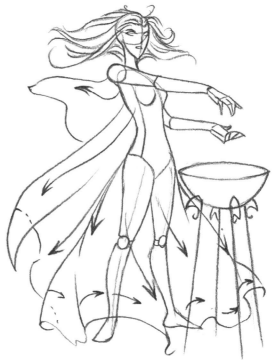

WITCH SUMMONING EVIL SPIRITS

The cape is a great device that we associate with evil. It also catches the wind, making it seem as if nature is being summoned to do the witch's bidding.

PRIMITIVE WITCH CASTING A SPELL

Note the animal head, fur garment, and belt and ankle bracelet made of animal teeth, all of which give her special powers.

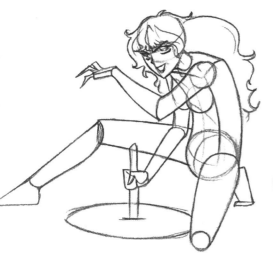

Soul-Snatcher

A dispassionate, almost sublime bad guy can be the cruelest of all. He is emotionally detached from the pain he inflicts upon others. This Prince of Darkness sucks the souls right out of the two young innocents who had the misfortune of wandering into his lair. This is how this villain stays young: by stealing the life force from others.

A detail of the decorative motif.

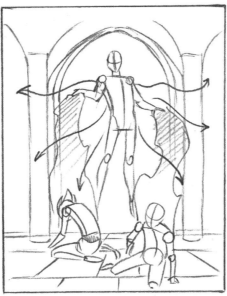

The thumbnail sketch focuses on points of interest. Bodies are blocked out, with indications for the cape radiating out in all directions.

A construction detail of the villain's head.

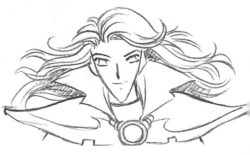

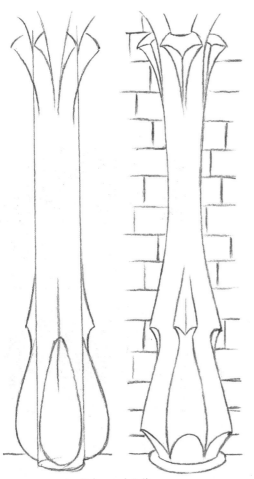

Column detail.

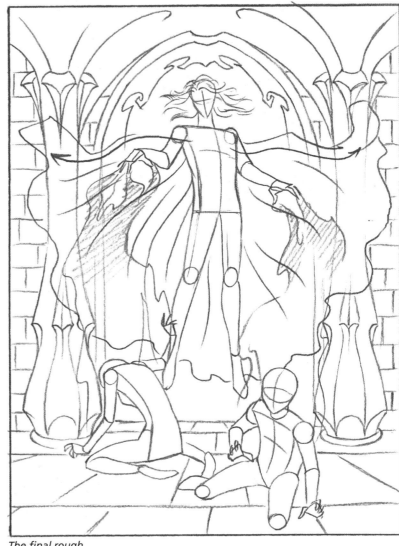

The final rough.

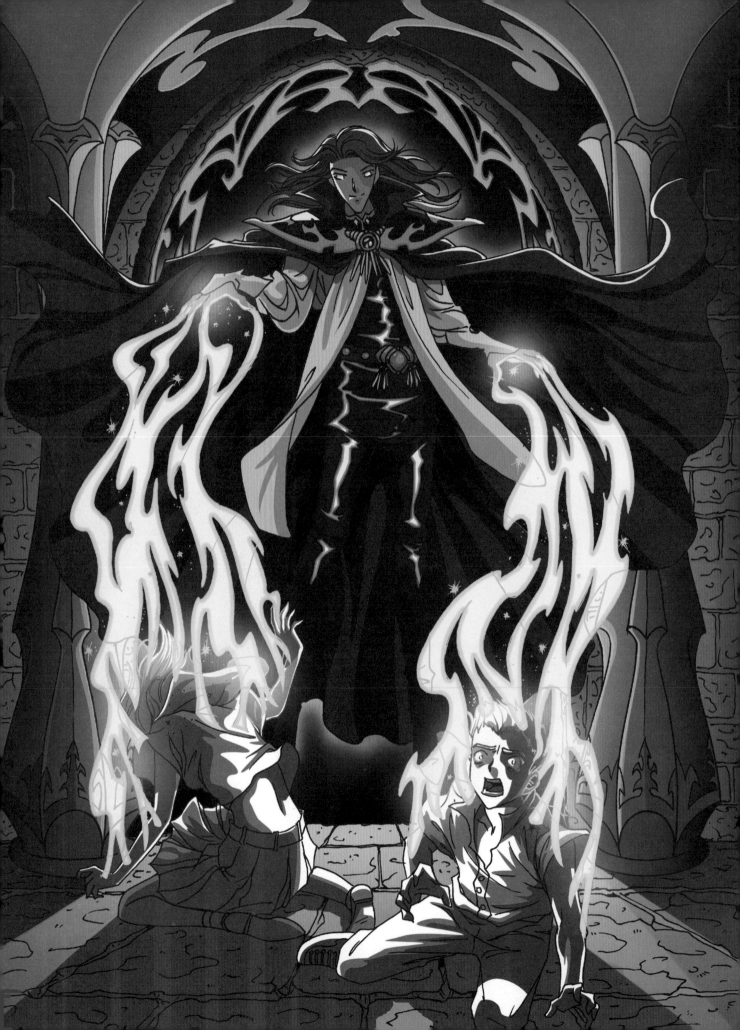

Beautiful Apparition

Apparitions are often beautiful and alluring, tempting desperate or lost travelers to follow them deeper and deeper into the woods from which there will be no return. The billowing costume and fantasy hair give the appearance that this apparition is floating in air. It's important that her feet not be visible here, which would ruin that effect.

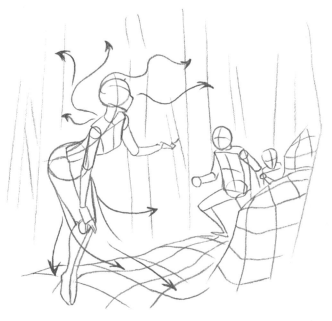

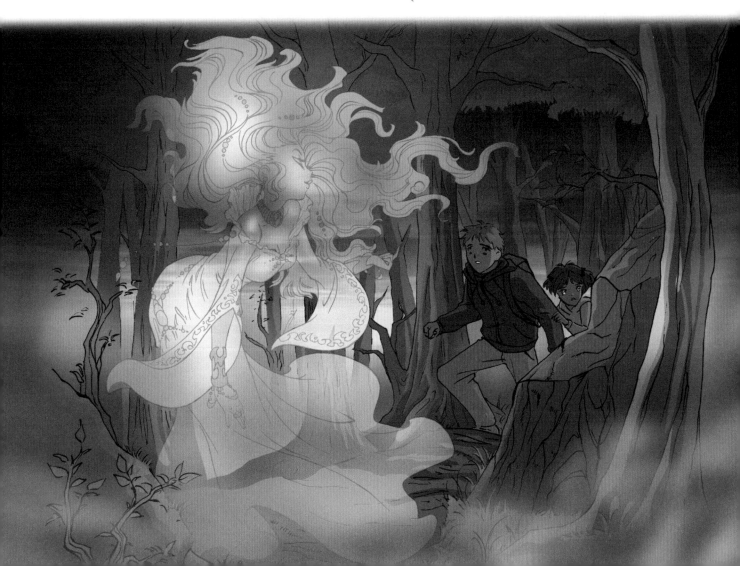

Glamour Thief

She'd never steal a car. She'd rather steal a cool billion from a corrupt CEO and buy herself a Ferrari. She moves under the cover of darkness. She dresses for work with the same attention to detail as any other professional. She wears a sleek bodysuit—which is reflective and shows off her great figure—cool gloves and boots, a belt to carry her climbing gear (you didn't think she just walked through the front door, did you?), and a few weapons, such as that knife tucked into her boot.

Alluring Invaders

The glam alien is beautiful but deadly. She views Earthlings as pests. And though she may have the face of an angel, she has the heart of a cold-blooded killer. There are many simple devices you can use to turn a good-looking woman into an alluring invader from outer space, including spacesuits; strange eyes (including unnatural iris colors); unique skin pigment; unique ears; baldness or a strange hairdo; a tail; fins; scaly skin; gills; wings; fewer fingers; cyborg implants; bony protrusions from the spine, knees, or elbows; and antennae.

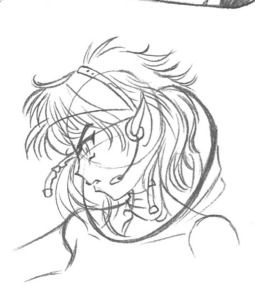

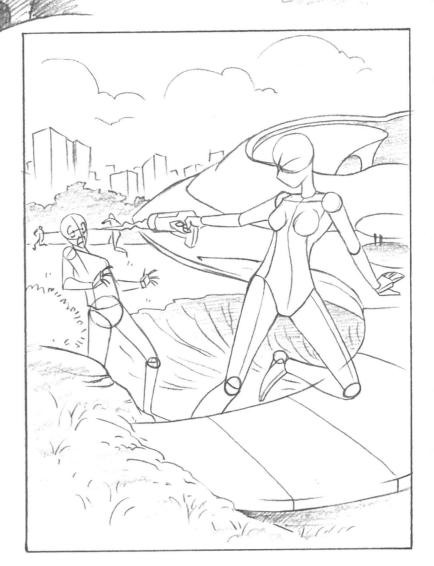

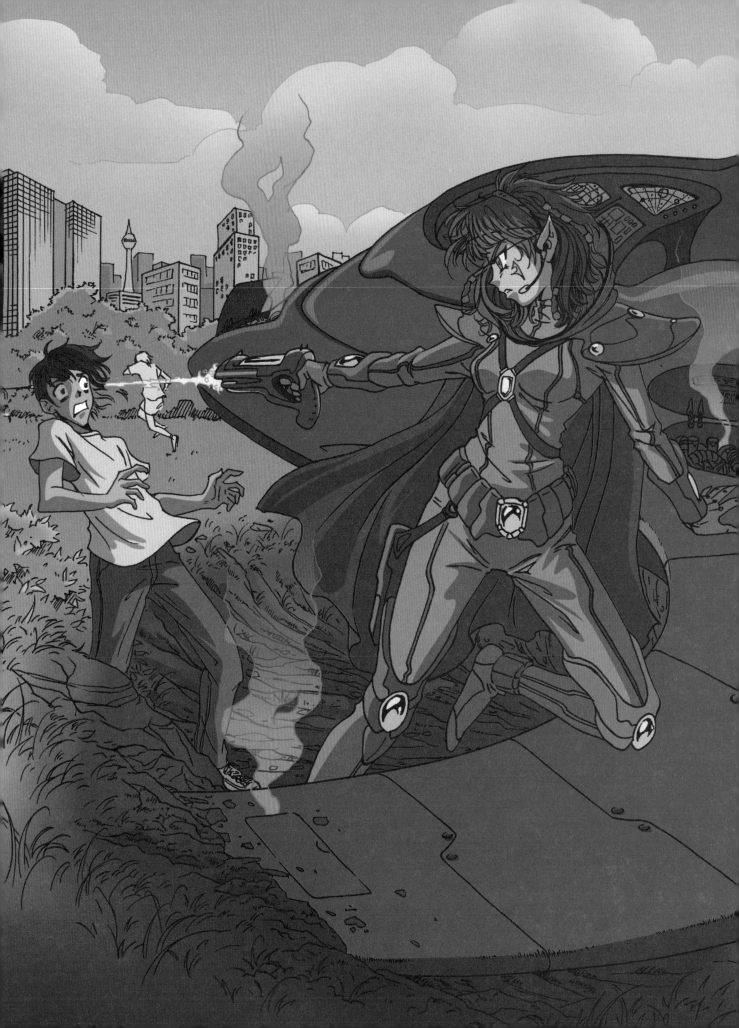

Grunge Glamour

This social outcast is pretty, tough, and trashy. She likes to wear tank tops and clothes from secondhand stores. She loves accessories—bracelets, necklaces, and gloves. Her hair should be long and wild. Her eyes are dark and sultry, with a generous helping of makeup. And, take note of what her body language is saying: "You want to make something of it?" She has way too much attitude, but it works for her mainly because of that gun tucked into her jeans. She needs it when she pays a "call" on a client.

Medieval Villains

Medieval villains are a feast for the eyes. They come with a huge array of opulent costumes and decorative weapons. There were always secret power plays going on behind the scenes in a castle, with different characters vying for position, swearing allegiance to royalty, and then betraying them. You had the ruthlessness of the king's executioners and the cunning of the queen. In other words, these characters make pretty cool bad guys.

EVIL PRINCE

A prince makes a better villain than a king, because he comes with a built-in motivation: He wants his daddy's money and power. The villainous prince is not brawny; he's delicate, having grown up pampered and spoiled. He loves the trappings of wealth. He wears long gloves and tall boots. His shoulders are padded to make up for his slight stature. He doesn't go anywhere without his crown, just in case—heaven forbid—someone doesn't know who he is.

KNIGHTS AND ARMOR

I know this will come as a stunner, but not all knights were nice. Maybe it had something to do with the fact that they were wearing tin cans and roasting in the hot sun. Nah. But how can you tell a good knight from a bad one? I mean, even the good knights were busy bashing heads. It's all in the helmet. A villain's helmet has horns, wings, fangs, or some other animal motif. A hero's helmet is less ornate, more functional. The villain's armor typically has shoulder plates that are built up with aggressive spikes.

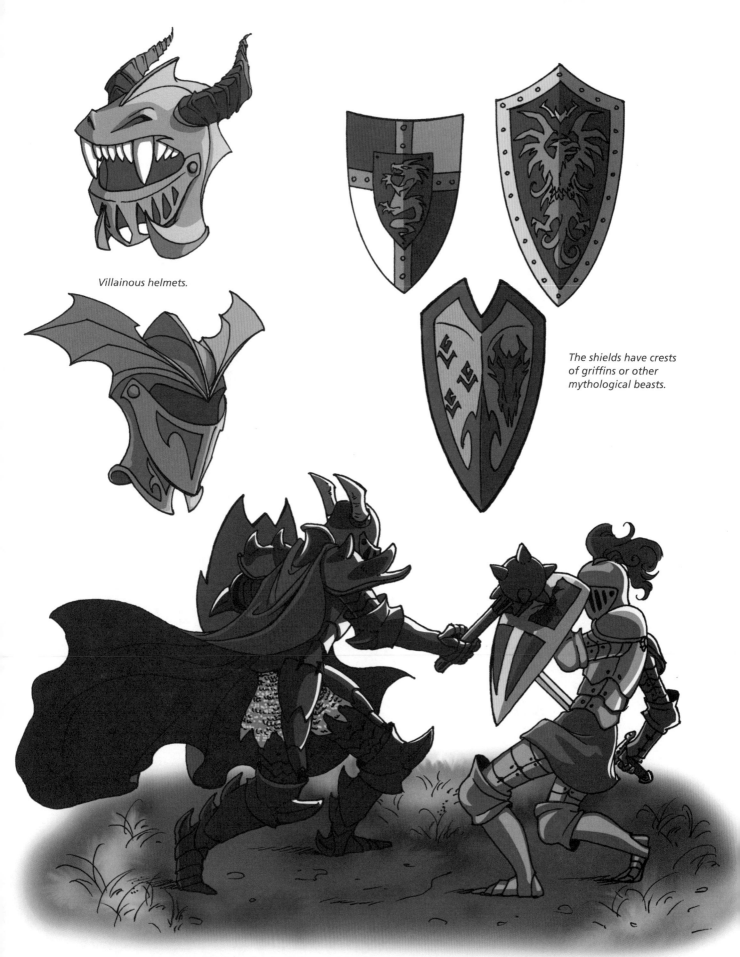

Villainous helmets.

The shields have crests of griffins or other mythological beasts.

Comic book rule of thumb: The bigger knight is always the bad one.

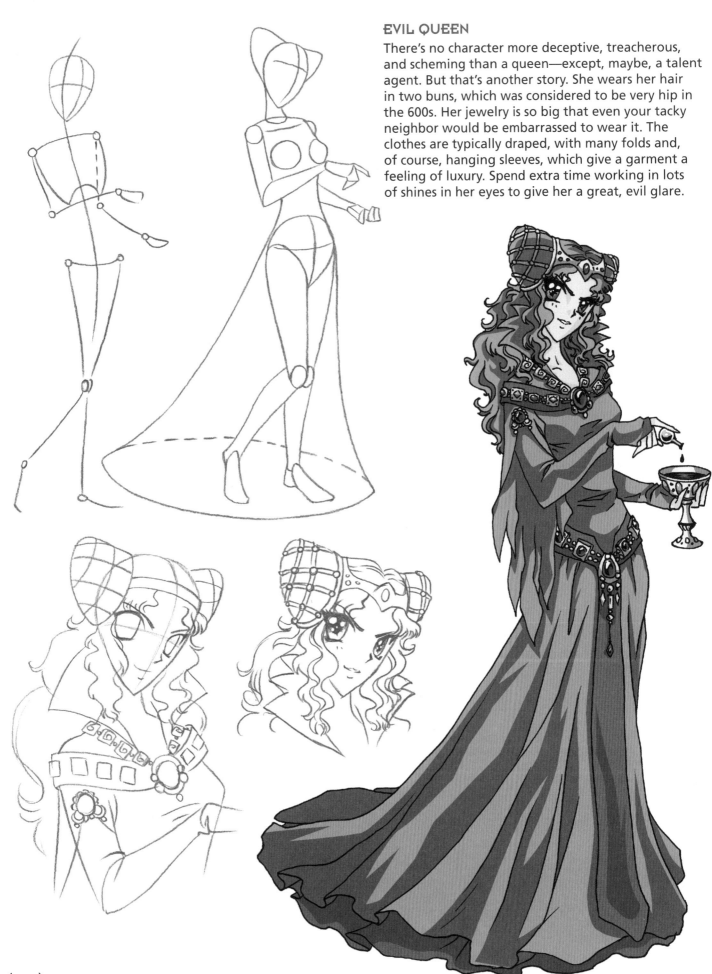

EVIL QUEEN

There's no character more deceptive, treacherous, and scheming than a queen—except, maybe, a talent agent. But that's another story. She wears her hair in two buns, which was considered to be very hip in the 600s. Her jewelry is so big that even your tacky neighbor would be embarrassed to wear it. The clothes are typically draped, with many folds and, of course, hanging sleeves, which give a garment a feeling of luxury. Spend extra time working in lots of shines in her eyes to give her a great, evil glare.

RAMPAGING KNIGHTS ON HORSEBACK

The horse should be ornately costumed and also wear a helmet; it's not just transportation, it's a fighter in the cause. Treat it as a character in its own right. It's especially important that the horse of the wicked knight wear a helmet. The more faceless the enemy, the scarier he or she is, and the knight and the horse meld into one unit: an unstoppable fighting machine.

Notice the knight's posture. He's leaning forward in attack mode, ready to strike. This is the standard posture for villains on horseback.

Medieval Weapons

The middle ages sure did produce an amazing variety of ways to inflict horrible wounds. And plague! They were also great at spreading plague, so you've got to give them credit for that, too. Since they had no gunpowder, their weapons sliced, bashed, or were shot through the air by recoil tension (bow and arrow, catapult, and so on). Let's take a stroll down evil memory lane.

SMALL MACE
This is a smaller mace, which was commonly used, as opposed to the great mace, which was a ball with spikes at the end of a stick.

BATTLE-AXE
Could be wielded with one or two hands.

MORNING STAR
The morning star sounds like a cup of java, but no, it's a bashing instrument. It's similar to the great mace but with two or three bludgeons.

DOUBLE-BLADED AXE
When one blade just won't do.

DOUBLE AXE
Never talk back to an ogre with an axe. They're just not in the mood to listen.

BOW AND ARROW

The crossbow came later. During medieval times, it was the bow and arrow. If you want to really get dramatic, show the arrow tips set on fire as they're being shot.

SPEAR/AXE COMBO

In the old days, you could get this great two-for-one instrument at your local weapons mart.

SINGLE-HANDED SWORD

It's not formidable-looking, but it was easier to control.

DOUBLE-HANDED SWORD

This sword was quite heavy, so it could only be swung using two hands. Make sure the handle is extra long.

DAGGER

A favorite of queens. Can be hidden in the clothing.

93

Blocking Out a Medieval Scene

This image puts it all together in one spectacular scene involving a good knight, a bad knight, a damsel in distress, and demon spirits. First, you'll want the most dynamic placement for the figures. Sketch a grid over your image area that divides the picture into thirds both horizontally and vertically. This is a time-tested trick used by many professional artists. It's called the Rule of Thirds and states that any place in the composition where two lines on the grid intersect is a good choice to be a point of interest in the image. In this example, of the four possible intersecting points, the top left and bottom right ones (points A and B, respectively) have been chosen. The next important step is creating factors that tie one point of interest to the other, and this is done with the demon spirits, which travel from focal point A to focal point B.

The Rule of Thirds.

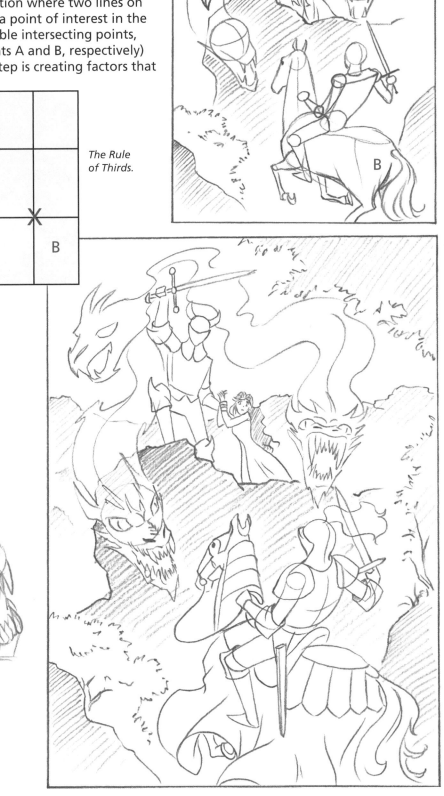

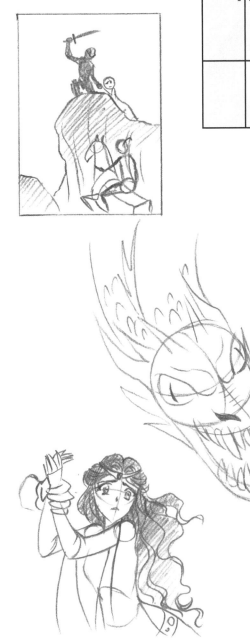

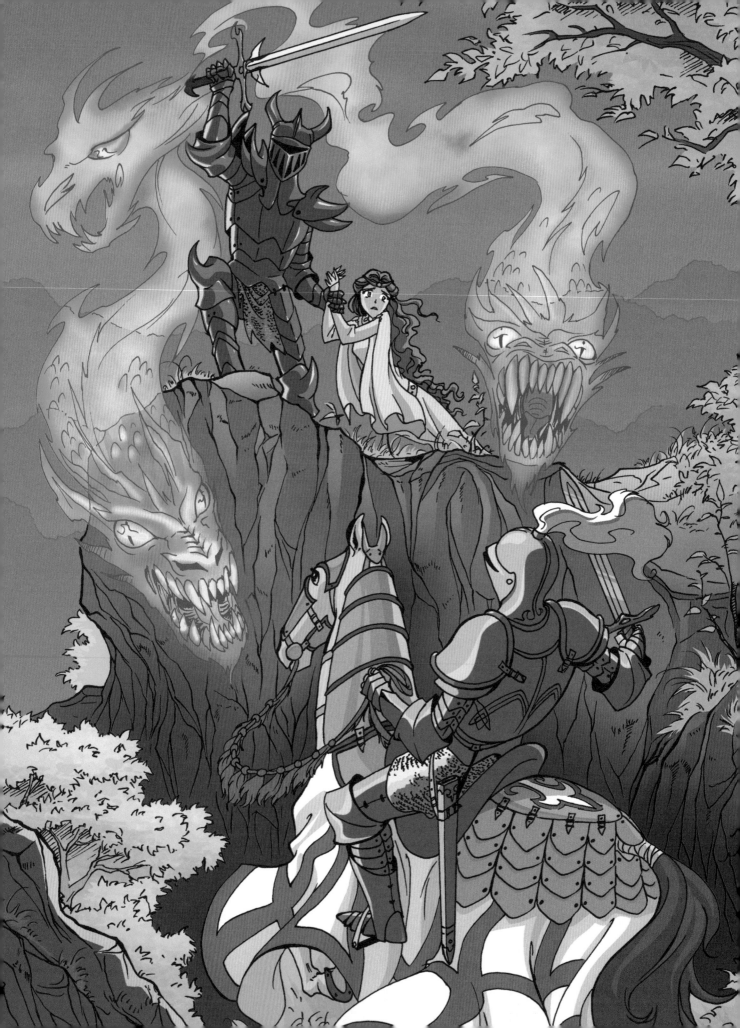

EVIL ACTION! EVIL POWERS!

Action is the name of the game. Everyone looks forward to an action-packed scene that makes your blood pressure rise. If you've tried to draw action scenes, you know that it's tougher than it looks. But, there are specific principles that, when followed, will make your action scenes come alive. Then you're going to want to give your "baddest" villains maximum evil powers, which create some of the most memorable action in manga.

Action Poses

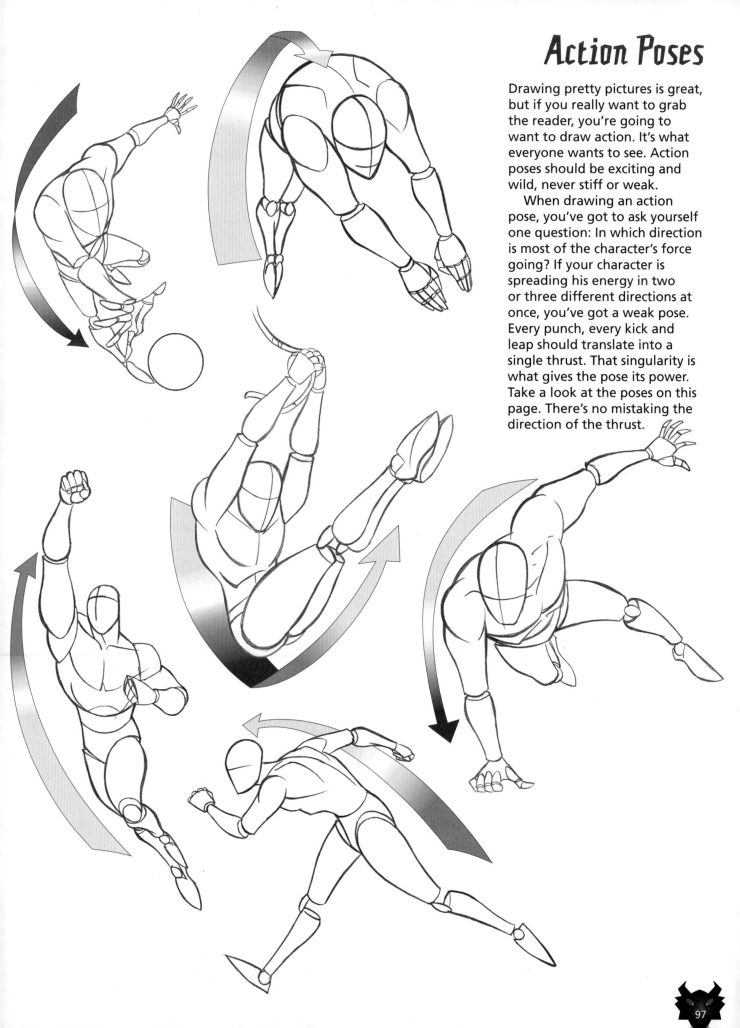

Drawing pretty pictures is great, but if you really want to grab the reader, you're going to want to draw action. It's what everyone wants to see. Action poses should be exciting and wild, never stiff or weak.

When drawing an action pose, you've got to ask yourself one question: In which direction is most of the character's force going? If your character is spreading his energy in two or three different directions at once, you've got a weak pose. Every punch, every kick and leap should translate into a single thrust. That singularity is what gives the pose its power. Take a look at the poses on this page. There's no mistaking the direction of the thrust.

Action Scenes

The action scene is the reward your readers get for hanging in there with the story. It's the big payoff, so you've got to make it splashy. To make it extreme, the characters in the scene must be equally active—the attackers as well as the victims. Both combatants in the scene take on active roles. This will create a sense of excitement and keep your readers glued.

CHASING A DEMON

With single-minded intensity, this armored soldier tries to capture and destroy an elusive flying demon. Note how close behind the demon the warrior is. The closer the combatants are, the more exciting the moment becomes. Fights or chases at long distances are anemic.

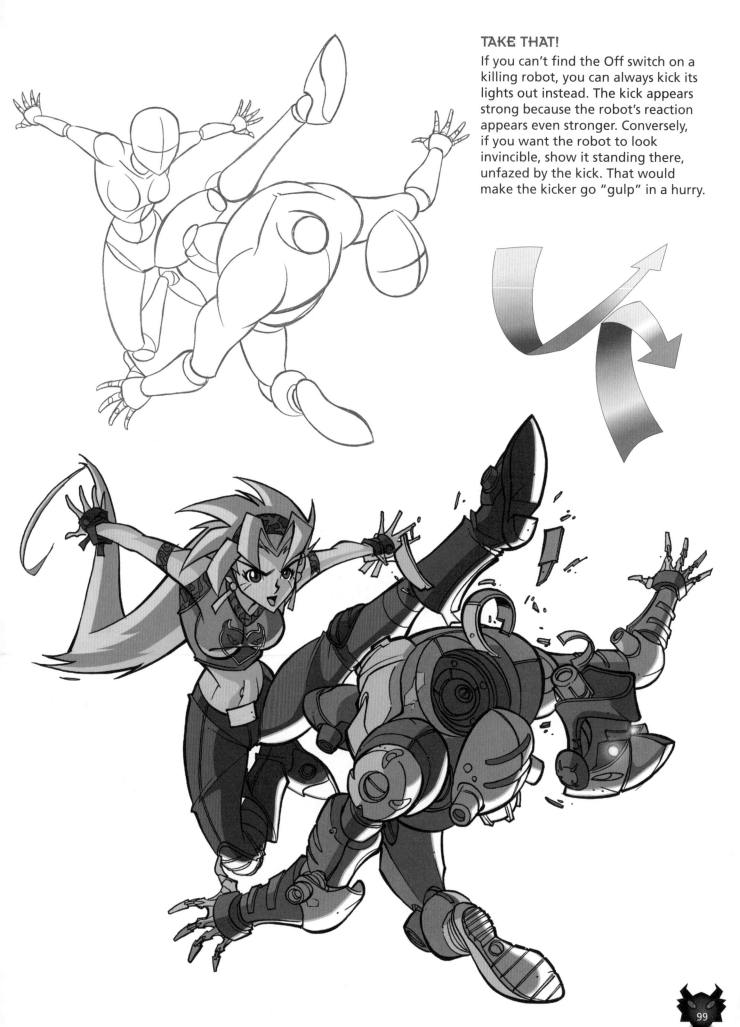

TAKE THAT!

If you can't find the Off switch on a killing robot, you can always kick its lights out instead. The kick appears strong because the robot's reaction appears even stronger. Conversely, if you want the robot to look invincible, show it standing there, unfazed by the kick. That would make the kicker go "gulp" in a hurry.

SAY YOUR PRAYERS, METAL FACE

When you play sports, you're generally coached to conserve your energy. You're cautioned against taking wild swings and about keeping your stance tight and controlled. In manga, it's just the opposite. Characters in action scenes should have their limbs outstretched and all over the place. There's no economy of motion here. Let the limbs fly; don't keep them close to the body. Big motions translate into big excitement.

HA! YOU MISSED ME

Two warriors can have seemingly unrelated lines of action and yet still create a cohesive action, as is the case here. The robot warrior punches as the female warrior leaps backward into the air, arching out of the way of the blow. Brute force is met with grace and agility. Humans: 1, Robots: 0.

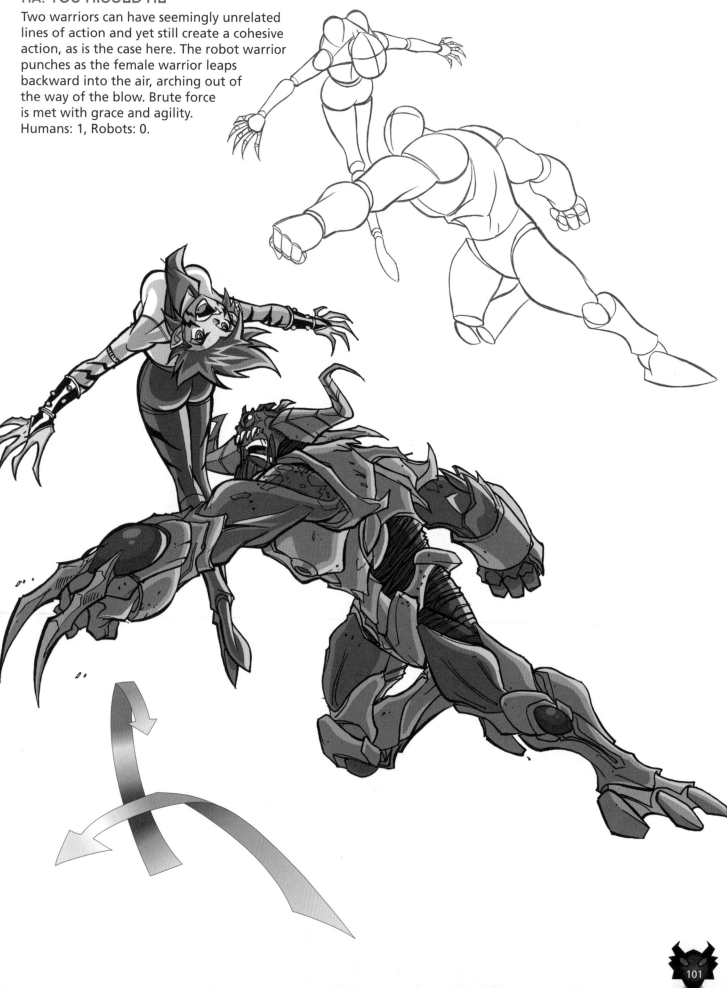

Monsters in Silhouette

One of the most powerful weapons monsters have is their numbers. Since they place no value on life—neither theirs nor their enemies'—they can come at their opponents in waves, overwhelming them with sheer numbers. This creates all sorts of great action in a scene. So what if a human blasts a few dozen to smithereens? It only takes one monster to get through and destroy the Earthlings.

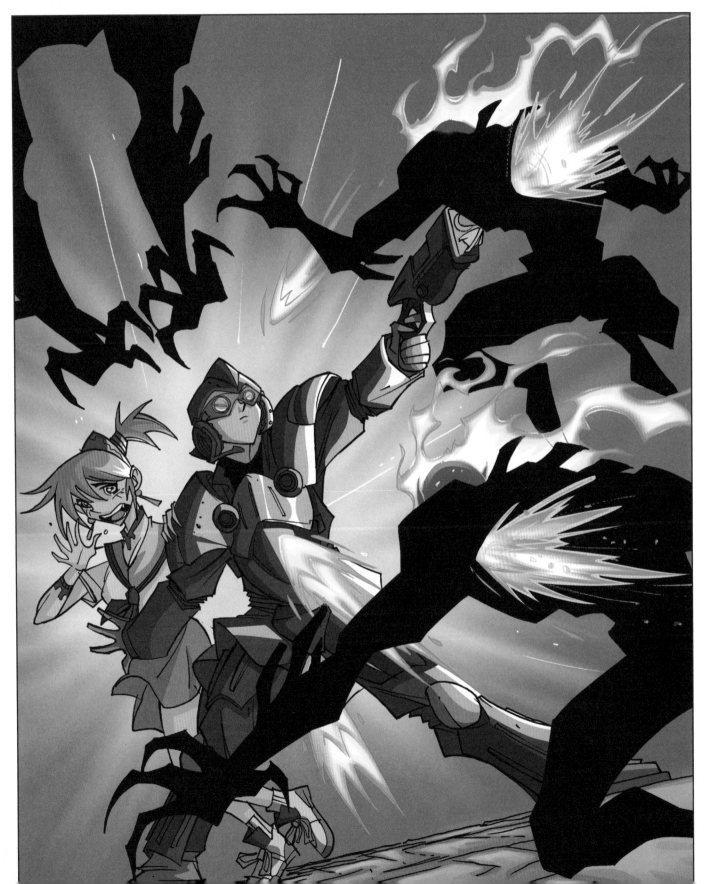

Fighting Dirty

Think all fight scenes are the same? Two characters battling it out with fists? Think again. Bad guys *never* fight fair. They use any advantage they can find, no matter how underhanded, ruthless, or cowardly it is. And that really grabs readers. Why? Because readers are outraged that the villain's craven attack has worked, and so they jeer the bad guy. Congratulations, you've made your readers feel that they have something at stake in the outcome of your story. That spells success for a manga artist. Here are some of the more popular methods that bad guys use to beat the nice guys.

THREE ON ONE

This old standard works every time. Two bad guys grab the hero while the third administers some "gentle coaxing." The bad guy never wants to fight fair—I mean, why risk a bad outcome when you can ensure a good one? Heck, only a dopey good guy would do something like that. If you're bad, you stack the odds.

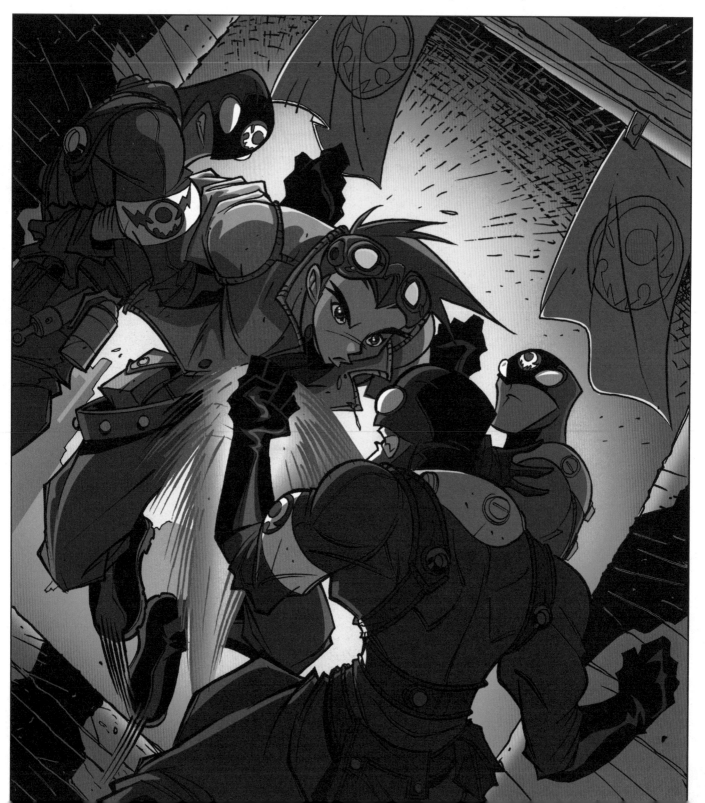

HIDDEN WEAPON

Put up your dukes? Sure, so long
as you're unarmed and I've got
a taser gun. Never let the heroes
see what you've got hidden under
your jacket—until it's too late.

IMPROVISED WEAPONS

You're a bad guy and you've been beaten but beaten good. Now, you're about to go down for the count. The hero has given you one last chance to give up peacefully. Are you grateful? Do you say uncle? Get real. You reach for anything you can—in this case, some dirt on the ground that you fling in his eyes, temporarily blinding him.

SNEAK ATTACK

It's so much easier to win a fight when the other guy doesn't know he's in one. The good guy can't throw a punch if his back is facing you. So, always have your villains launch sneak attacks from behind. And use a weapon of some sort, too. I mean, as long as you're already being unfair, you might as well be even a little more unfair to ensure victory.

EVIL ACTION TIP

Here's an important secret to creating good villainous action scenes: The "badder" the bad guy is, the more exciting the action will be, because your heroes will have to use all of their strength to defeat him. So, instead of building up your good guy, build up your bad guy.

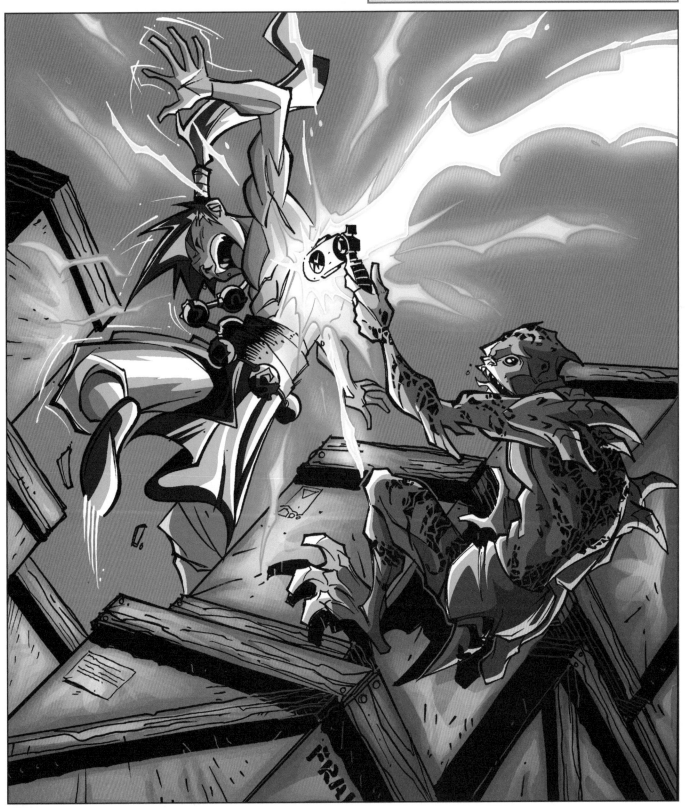

Evil Powers!

Manga fans want to see special powers. It's the highlight of most anime TV shows. As villains with no morals, these characters should be all too willing to throw their weight around. Design powers that are visually dynamic and not too conceptual. You shouldn't have to explain the powers to your readers; they should be easy to grasp and part of the action.

Consider the type of character when designing special powers for him or her. If you've got a brute, then giving him telekenetic powers goes against his type. He needs superstrength. Also, try to be inventive. For example, flying is a special power but one that has been around since the golden age of comics. If you want your character to fly, then do something with it.

Perhaps he flies so fast he turns into a multiheaded bird of some sort. So, when you think of a power, dig a little deeper and find a way to make it cool.

TECHNOWIZARD

She can invade any computer with her mind, controlling all the systems and gaining immense power. She can wreak havoc on military bases, commercial industries, and cities. Water supplies, electrical power, and the Federal Reserve Bank are shut down when she boots up. She can think her way into the computer system. She can enter the computer system at Fort Knox and program it to deliver all of the nation's gold to her front door.

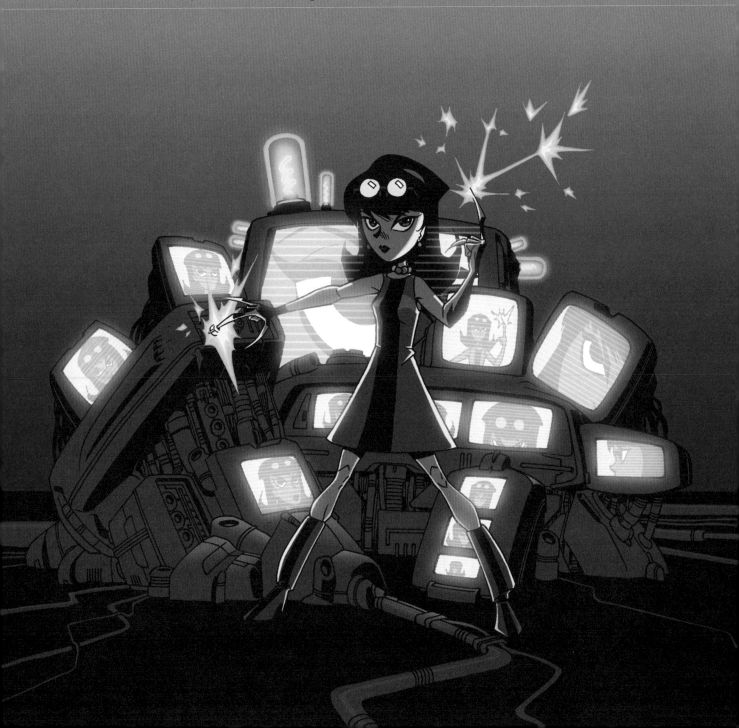

FISTS OF DYNAMITE
Super-duper strength ain't nothin' new. So, tweak it. How about a villain whose arms and fists grow to mammoth size when he throws a punch so that they flatten his opponents like a steamroller?

BEASTLY TRANSFORMATIONS

The beast that comes out during the transformation doesn't have to resemble the original, human villain. In fact, it's more startling and effective if the beast looks completely different. The costume, however, should remain the same to help the eye identify who the character was and what he or she has become.

BODY SERPENTS

Here's a cool idea that's been gaining popularity in recent years: a beast with a mouth in its stomach. This evil power is great for the element of surprise and for the action it brings to the scene. A second "mouth" opens up from the stomach, unleashing weird things from inside the body. These snakelike creatures look to devour everything in sight. Once they've eaten their fill, the snakes will go back into the body and the mouth will close, concealing itself once more. A burp is optional.

MASTER OF CREATURES

A cool power is the ability to command others to do your bidding. I know because my wife has that power over me, and she thinks it's pretty cool. In the world of manga, the creatures your villains push around aren't spouses but gigantic, ferocious fighting things. They can appear out of thin air and disappear just as quickly, that is, after they have reaped sufficient death and destruction. You may be asking, Surely these creatures must have some good in them, way down deep? Yeah, right.

111

WEATHER CHANGER

The ability to create floods, tornadoes, and generally ruin a picnic is a powerful weapon—and provides some good action. Taken to its extreme, the power to create a blizzard means having the ability to bury an opponent in an avalanche or disable an entire city. And we're not talking about an overnight snowfall here; we're talking about 5 seconds of an amazingly violent, hurricanelike storm. The powers don't have to emanate from the character's palms, as they do here. Other popular conduits are: eyes, fingertips, knuckles of closed fists, opened mouths, and cyber devices built into the chest.

EXPLOSIVE FURY
Using the amazing force of her being, this character can cause matter to explode. A huge lightning bolt cracks the sky, adding to the action of the moment. And, if you want your explosion to pay off even bigger, prep your readers: Precede the explosion with a buildup in which the character closes her eyes, trembles with pent-up force, and begins to change colors. This adds to the suspense.

WEAPONS & ROBOTS

ust like cowboys out of the Wild West, manga
illains need to suit up for their showdowns.
ut instead of a holster, pistols, and spurs, they
port cyberweapons and body armor. Some
f these accoutrements are pretty cool. Take
look at the items your characters'll need.

Weaponized Arms

Amazing power can be derived from technoweapons attached directly to the body. Characters' reflexes are faster, because they don't have to grab for their weapons; they're just always there. One of the most popular attachments is the "weaponized" arm. In addition to providing assault capabilities, it also extends the character's reach and intimidation potential.

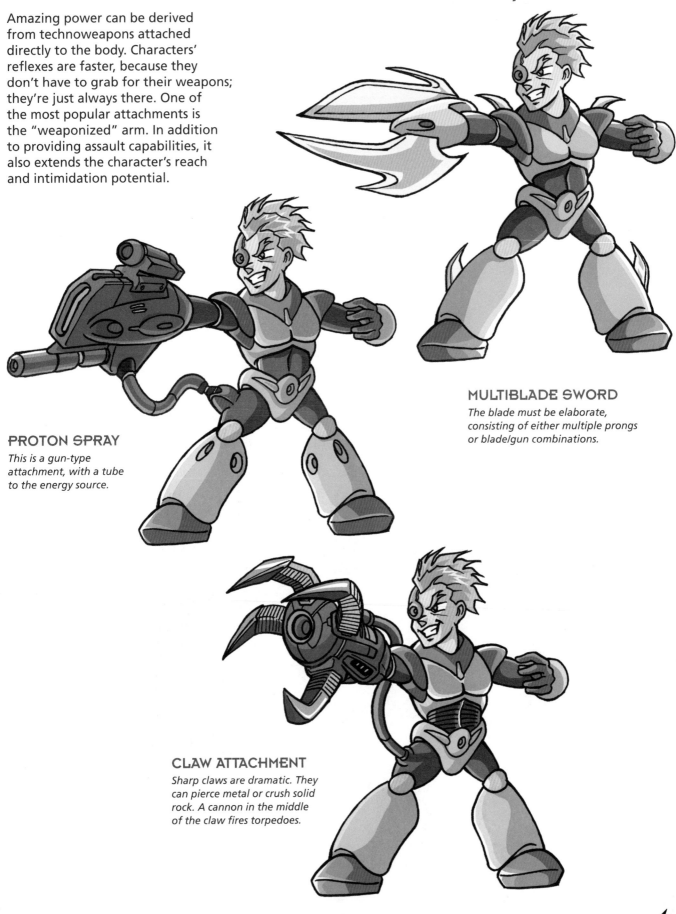

MULTIBLADE SWORD
The blade must be elaborate, consisting of either multiple prongs or blade/gun combinations.

PROTON SPRAY
This is a gun-type attachment, with a tube to the energy source.

CLAW ATTACHMENT
Sharp claws are dramatic. They can pierce metal or crush solid rock. A cannon in the middle of the claw fires torpedoes.

Multiple Arm Attachments

Why stop at one amazingly destructive weapon when you can have two? This guy has bought all the latest attachments. Is this overkill? Uh-uh. Over-the-top is a good thing in manga, where the villain with the most toys wins.

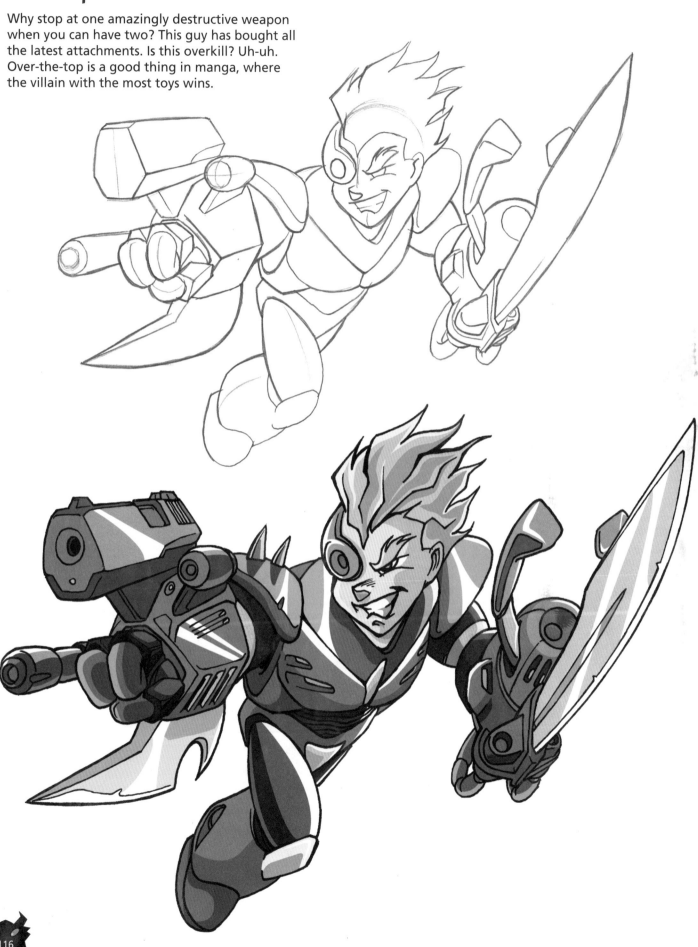

Multiple Blasts: Creating a Sense of Action

When you illustrate a scene, what you're really doing is drawing still pictures, not actual motion. So, how do you create the *illusion* of action with your artillery? By using multiple bursts to indicate gunfire. Never draw one burst coming from the nozzle of a gun when you can show two. And, if you can show three, so much the better. Be sure to space the blasts apart. This will make it look as if the character has fired multiple shots, conveying a sense of real action and movement though your character is actually standing still.

HANDBLASTERS:
THE BAD GUY'S WEAPON OF CHOICE

The handblaster is a favorite weapon for bad guys. It can be taken out and used when necessary, then tucked into a jacket and not seen again until the next time it's used. That's not so easy with bigger weapons, because they cannot be tucked into the pants after they've been used, unless you're a rapper. Then you can fit a condo into your pants.

Giant Guns

Although they take a little more effort to draw, the big guns are scene stealers. Whether blasting giant robots or retreating armies, bad guys with major firepower control the action. These big guns should be futuristic, often firing from more than one opening. Create patterns out of their compartments, for interesting visual effects.

LASER RIFLE

The prongs focus the energy at a point and then shoot it out in a highly charged stream.

LASER GUN

Beefy and powerful, some manga-style guns are purposely drawn oversized to create an impressive look.

SHOULDER-MOUNTED LASER

Sometimes, a weapon is so big it has to be held on the shoulder, but this also frees up the other hand.

Mean Machines

Just like anybody else, villains need transportation to and from work. The only difference is that their work is plundering and stealing. Hey, it's a living. Packs of outlaw bikers roam the streets—or I should say *above* the streets—on rocket-powered motorcycles. These bikes should be low riders with big engines up front and plenty of beefy exhaust pipes. Note the chopper-style handlebars. The pointed front end underscores the mean look and serves to cut through the wind.

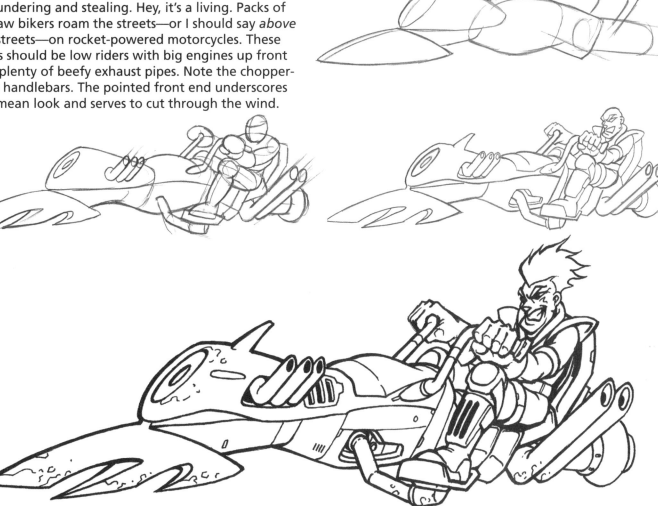

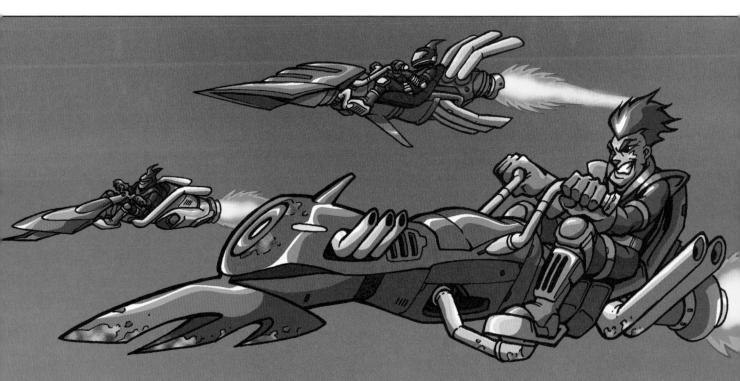

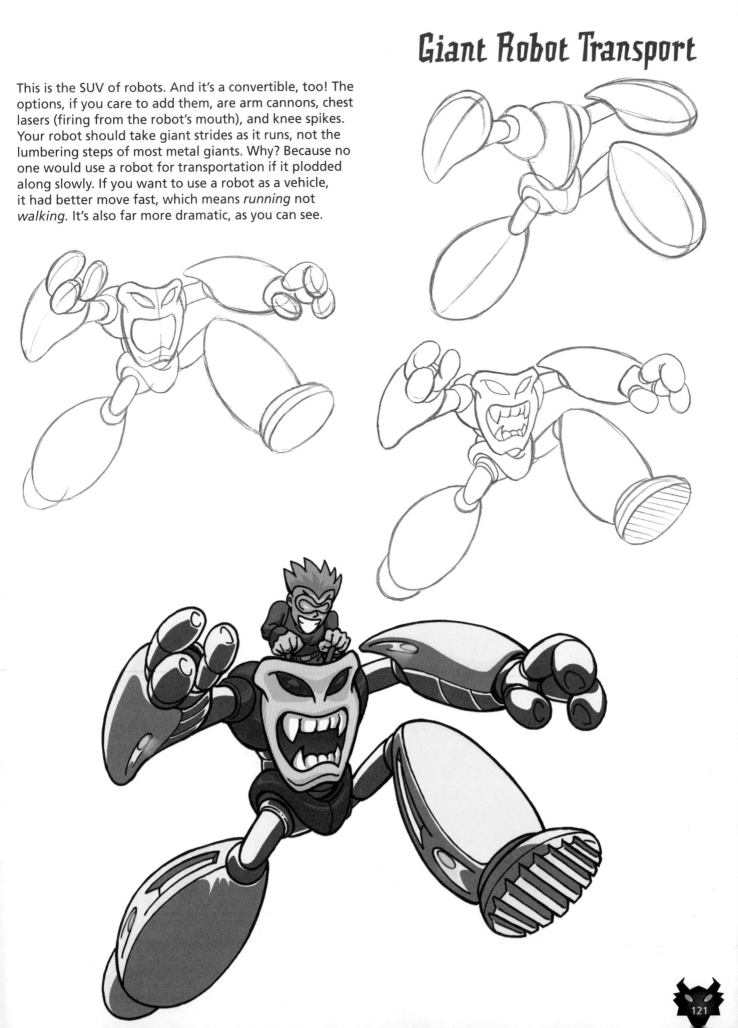

Giant Robot Transport

This is the SUV of robots. And it's a convertible, too! The options, if you care to add them, are arm cannons, chest lasers (firing from the robot's mouth), and knee spikes. Your robot should take giant strides as it runs, not the lumbering steps of most metal giants. Why? Because no one would use a robot for transportation if it plodded along slowly. If you want to use a robot as a vehicle, it had better move fast, which means *running* not *walking.* It's also far more dramatic, as you can see.

Evil Robots

There are bad robots and then there are *BAD* robots. Any evil person can command a robot to do evil but that doesn't make the robot itself an evil warrior. To give a robot a wicked persona is to ratchet up the stakes in a story. It's bad enough to fight a giant robot, but how about one that likes its job?

TURNING A GOOD ROBOT INTO AN EVIL ROBOT

An effective method of designing an evil robot is to start off by drawing a good robot and then making a series of adjustments until it is the king of badness. Going step-by-step through the process illustrates how a bunch of little changes add up to a major difference.

Keep in mind that you can stop at any point in the transformation. You may prefer your robot only a little evil, in which case an early variation would work for you. Or, you may want it really, really evil, in which case you'll want to ride this out to the last image. It's up to you. You're the artist.

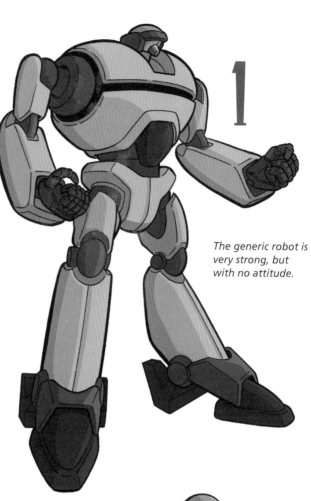

The generic robot is very strong, but with no attitude.

The first thing we do is build a set of aggressive weapons into the arms. Add reinforcements on the torso and calves to indicate that it's gearing up for battle.

Increase the number of guns so that each arm has two powerful weapons. The wrist guards become divided into separate units so that the hands/guns can rotate in any direction in a flash.

4

Replace the two pairs of arm guns with beefier weapons. The hands open as if they're ready to crush. Add dynamic shoulder flares. The chest has been sculpted so that it protrudes pointedly.

5

Add horns to the helmet, which has become more elaborate. The part of the helmet above the eyes acts like eyebrows, forming an evil frown. Replace the previous arm guns with massive firepower; each arm is now capable of firing 10 rounds simultaneously. Add stabilizers between the shoulders (to steady the robot during flight) and recessed rocket boosters in the shoulder flares.

6

To go all out, virtually replace the arms altogether with humongous guns. Install a crushing mouth in the chest. Put giant spiked knee guards on the legs and spikes on top of the elongated boots. Now who's the boss?

123

Crusher-Destroyer

Here's a real bruiser. It just loves to play with things. But the things don't look so good afterward. This is a standard robot type in manga. So how do we immediately recognize it as evil? First of all, the eyes are evil; they're small and beady, and surrounded by a dark mask. Second, the horns on the head turn forward, aggressively, with satanic overtones. Third, the arms are long and apelike, reminiscent of a silverback gorilla. And fourth, the head is placed very far forward, almost on the chest, which makes the shoulders look extremely massive and creates a feeling of raw, brute power.

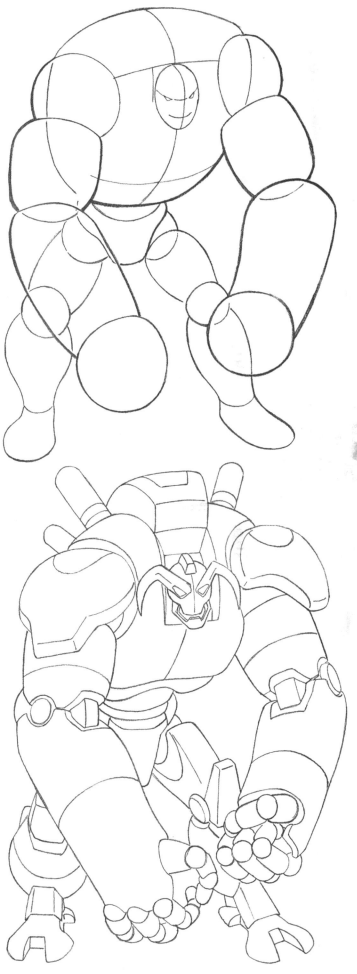

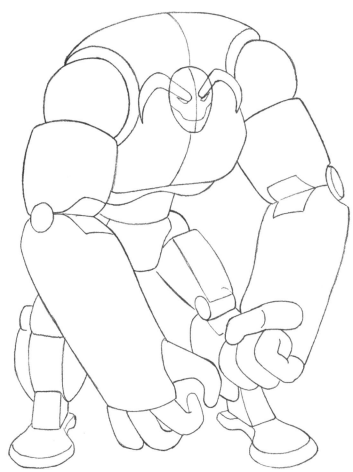

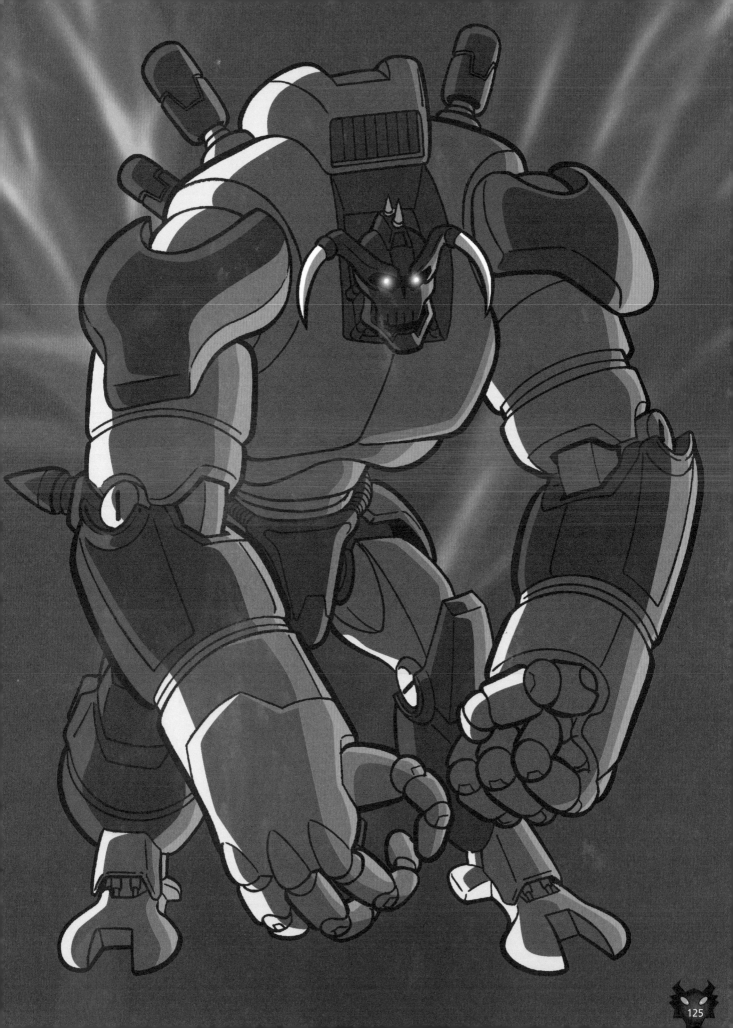

Goth Robot

It's 3/4 gargoyle and 1/4 pterodactyl. In comics, prehistoric featherless pterodactyl wings are seen only on evil creatures. So, putting them on this gothic machine already goes a long way toward creating a robot of darkness. But it's not done yet. The repeated motif of the spines, spikes, and horns screams wickedness. The narrow slits for eyes are also indicative of evil. And there are birdlike feet with nasty talons, which, along with the hand claws, are formidable weapons.

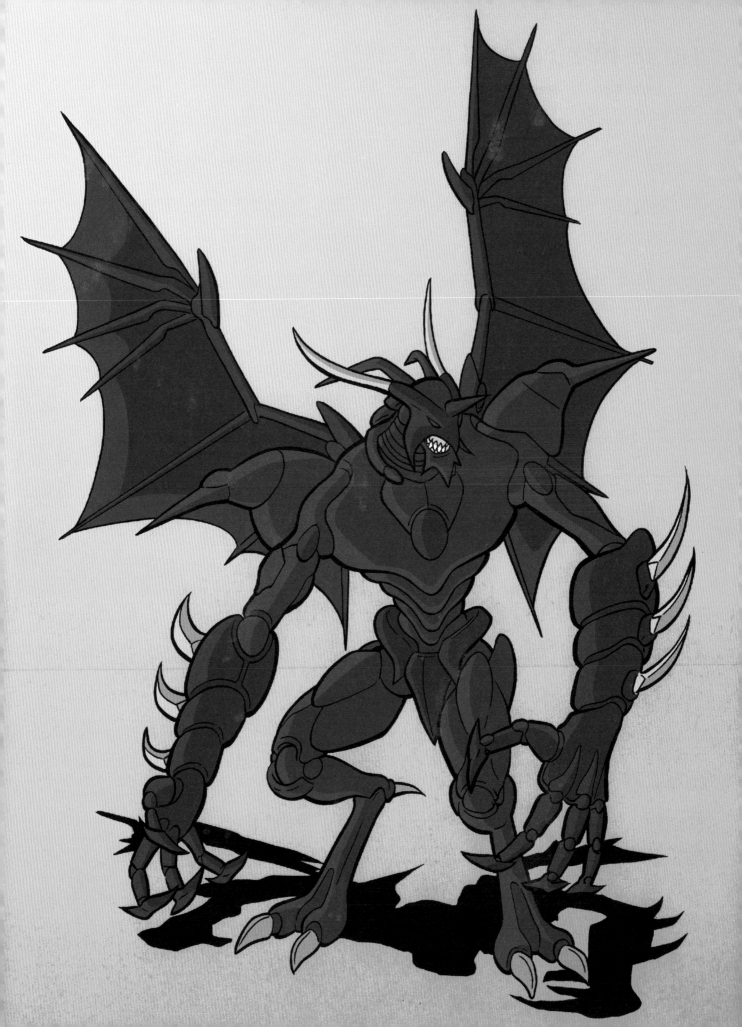

Three-Headed Bird of Prey

A robot with three, fire-breathing heads can take on a
fleet of good guys and still be back in time for an oil
change. With three maneuverable heads, it picks off good
guys with the ease of an expert video game player. The
cool thing about a flame-throwing robot is that its attack
leaves such dramatic scars on the landscape. Instead of
bullet holes, there are long streams of flames where
the robot attacked, and a city left in flames and ruins.

Robot Triceratops

What do you get when you take a giant, prehistoric beast and cross it with an advanced mecha system? You get one of these. But unlike the original triceratops, this robotic creature can gallop at high speeds, use infrared scanners to see at night, and has motion detectors for pinpointing its target.

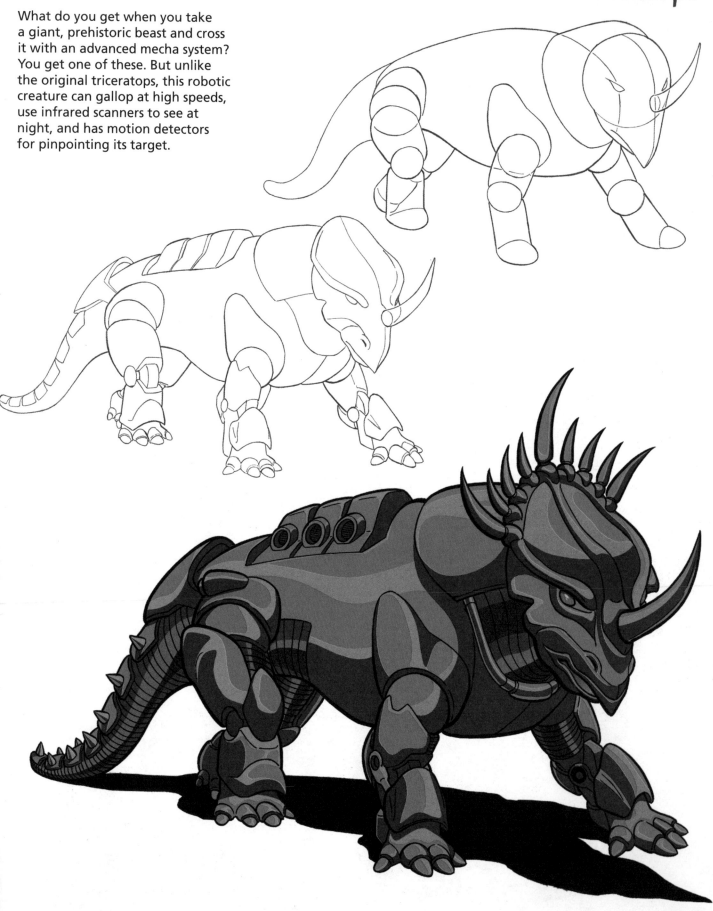

DRAWING COOL SCENES

We've covered a lot of ground up to this point, learning how to draw a great variety of characters. It's fun and great practice for you as an artist. However, there's more to comics than just drawing characters. If you think you might ever want to create your own manga or anime, you'll have to put your characters into scenes within panels. That means you'll need to know some design concepts. Here are the important principles with which you should be familiar and which can turn a ho-hum scene into an explosive one.

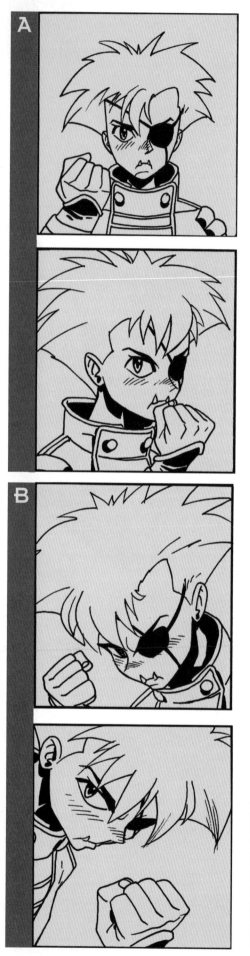

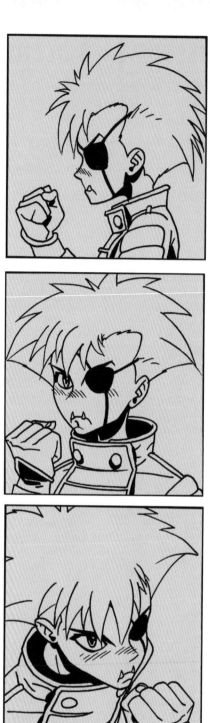

Dramatic Angles

To make a real impact on your reader, you've got to increase the intensity, and the most effective way to do this isn't necessarily to draw bigger biceps on your character. How you *show* the character—the angle you use—creates tension, suspense, and excitement.

There's more than one way to pose a character. Compare the images at left. They show what happens when you take a character in a typical pose—clenching his fist in anger—and show it from different angles. The four panels marked A, which the majority of beginners choose, are okay, but they're flat, they only show the subject head-on, and they don't make much of a statement. The five panels marked B show the angles the pros use. They create intense, dramatic poses. You can use A-type poses through nonessential parts of the story, but when you want to build up to a climax, you have to hit the B poses.

Drawing Two Characters in a Scene

When you put two or more characters in a scene, you're faced with a new challenge: From whose point of view will the reader view the scene? It makes a big difference. Let's see how.

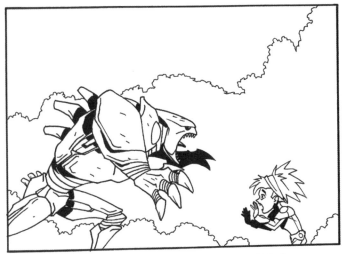

FLAT ANGLE, NEUTRAL POINT OF VIEW

Yes, the monster is big and the girl is small, but the layout is doing nothing to emphasize that disparity. Both characters are given equal weight. That's a no-no.

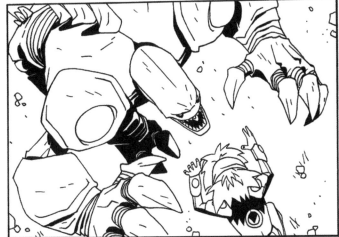

HIGH ANGLE, NEUTRAL POINT OF VIEW

Raising the angle so that the reader looks down at the characters creates a new point of view. But, it's still a neutral point of view, because it doesn't favor one character over the other.

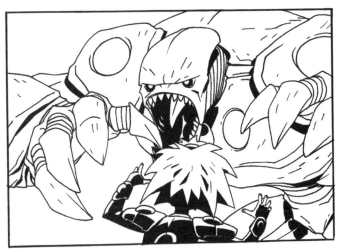

ANGLE FAVORING MONSTER

Now the angle definitely favors the monster, which clearly dominates the panel, overpowering the helpless victim. In this panel, we're looking up at the monster from the girl's point of view, which elevates the monster visually, emphasizing how it towers over her. This brings suspense and excitement to the scene.

ANGLE FAVORING VICTIM

The girl now appears framed and trapped by the advancing monster, which is so enormous it can't even fit into the panel. It's the monster's point of view of the scene, but it's her experience of the scene that we're feeling, not the monster's.

Using Shadow to Create Dramatic Moments

It's time to think of shadows as more than just shading. Shadows are also an important tool for increasing the stakes—the more shadow you use, the more urgent the action in the scene. Still, you can't just bathe every character in shadow. That would get tedious and make everything hard to see. The rule of thumb is that the closer you get to the character, the more shadow you can effectively use.

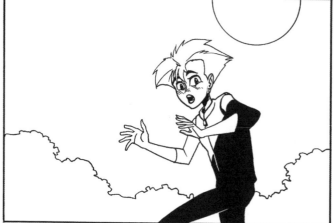

REVERSE ANGLES: SHOWING CHARACTERS TALKING

This is a typical setup: two characters talking to each other. How do you draw it? Well, you *could* draw them facing each other in profiles, but that's not usually the best choice; dual profiles emphasize both characters equally, when the one doing the talking should really get the greater weight. Instead, draw the character who's talking in a 3/4 front view, and overlap that figure with the character who is listening and who should be drawn in the 3/4 rear view. You simply reverse the angles of the two figures, hence the name *reverse angle*.

Silhouettes for Comics

Most beginners know what a silhouette is, but they think there's only one type: a person's face, usually in profile, blackened out. That's a good, basic understanding of the concept, but it doesn't go nearly far enough.

The silhouette is also a design element that's far more versatile than you might first imagine. You can use it to separate the three major elements of a scene—foreground, middle ground, and background—from one another.

BACKGROUND

By turning the background into a silhouette, you prevent the reader's eye from examining the background; as a result, the eye focuses on the character in the middle ground. The silhouetted background also serves as a nice contrast to the sky.

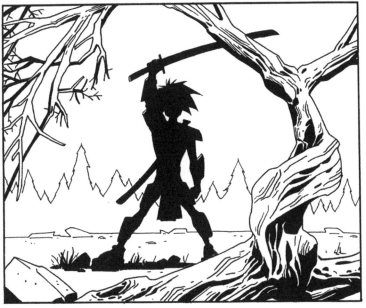

MIDDLE GROUND

Assuming that the character is in the middle ground, silhouetting this area can create a sense of strength and isolation.

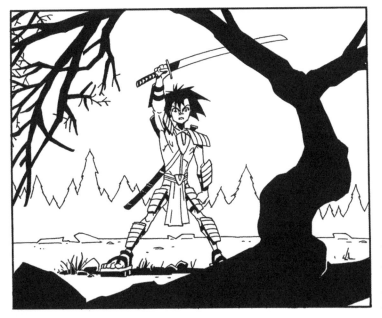

FOREGROUND

A heavily shadowed object in the foreground brings a heightened sense of suspense to the scene.

BACKGROUND

Here, the silhouetted background wall helps the windows "pop" (jump out at you visually), making a nice design motif. This focuses our attention on the girl and the creature equally.

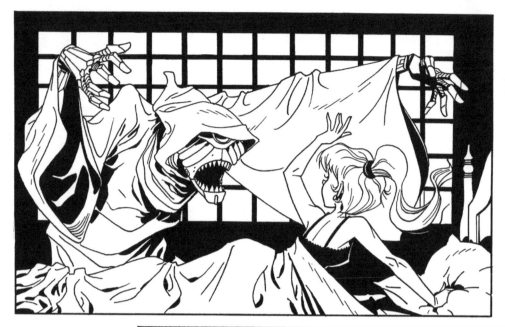

MIDDLE GROUND

Silhouetting the monster gives it an anonymous feeling, which has a different effect than does shading the woman (below). It makes the creature appear stealthier and more enveloping, and it focuses our attention on the girl.

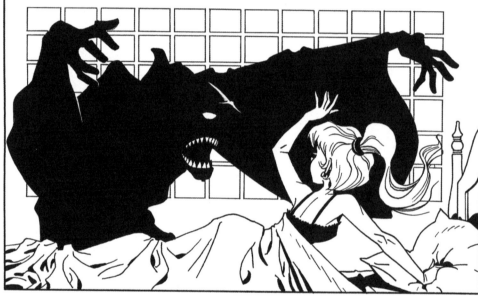

FOREGROUND

By silhouetting the woman in the foreground, we make her look anonymous. She then stops being a specific person and instead becomes just another victim of the diabolical hooded creature—yikes!—who becomes the focus of our attention.

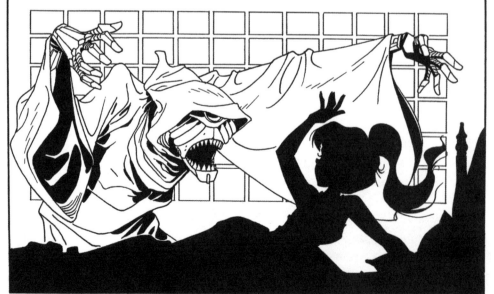

Secrets for Designing Comic Book Panels

In the beginning, artists confined themselves to the panel box. As the art form matured, artists began experimenting with the borders. Today, all the rules are being broken to great effect. However, it's only by *carefully* breaking the rules that you create impact. You want order, not chaos. You're trying to convey specific feelings—a sense of urgency, excitement, and suspense—through panel design, which means that everything you do must have a purpose.

AVOIDING A CLAUSTROPHOBIC PANEL

Imagine that the panel ends at the broken line; note how claustrophobic the panel would have been if the artist had tried to squeeze these two characters into that panel. It would have looked like they were in a tight elevator with their heads touching the ceiling. To let the panel breathe without having to reposition the characters, simply lower the top of the panel until it's behind the characters' heads.

BREAKING THE BORDERS

If you want to focus the reader's attention on an important detail, such as a gun, draw it outside of the panel borders.

THE NO-PANEL PANEL

Here's a cool trick to put in your repertoire: Let the action occur between panels. The empty space between the panels becomes, in effect, a panel itself.

ODD PANEL BORDERS

For a change of pace and a freer feeling, eliminate the lines of the border that aren't in contact with the character's body.

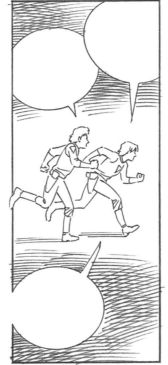

SPEECH BALLOONS

Comic book panels are sequential, which means that they leap from moment to moment in a specific order. The challenge to the artist is to lead the reader's eye to that next moment in a way that holds the reader's attention. One way to do that is to place speech balloons so that they overlap the panels. In this way, a speech balloon connects the panels it overlaps so that the dialogue seems to be going back and forth.

OPEN BALLOONS

If you have multiple speech balloons in a panel, it can get monotonous. In order to prevent that, open one of them up at the border of the panel.

Designing Cool Comic Book Pages

Before stringing your panels together, take a step back for a moment. Start thinking in terms of designing an entire page. Does that mean that each panel should move gently into the next so that the entire page flows? Not necessarily! Some of the best transitions are abrupt breaks that wake the reader up. Take a look at how some pages suffer from *too much* panel-to-panel flow.

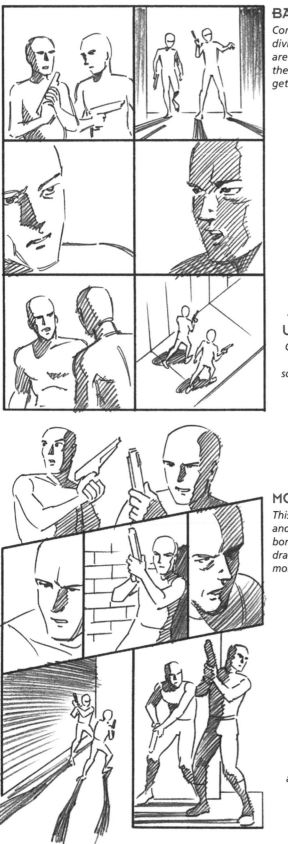

BASIC PAGE

Comic book pages that are divided into 6 equal panels are seamless but dull. It gets the job done but doesn't get you there in style.

BASIC PAGE WITH UNEQUAL PANELS

Creating panels of unequal length emphasizes some scenes over others. Still, this technique alone won't set the world on fire.

MODERN PAGE

This example uses diagonals and even panels without borders. It's much more dramatic—and the sign of a more accomplished artist.

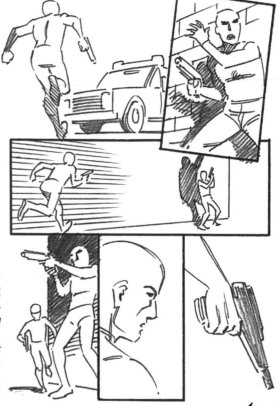

CUTTING-EDGE PAGE

This page has got it all: overlapping panels, tilted panels, borderless panels, and a wide variety of shot selections—long shots, medium shots, close-ups, and detail shots.

Putting It All Together

Now let's take a typical action sequence—a chase scene—and see how a beginner, an amateur with some experience, and a professional artist would handle it. Here's the setup: A male police officer is after a bad guy; the bad guy tears off down an alley, darts through an intersection, and thinks he's free when he's tagged by the cop's female partner. A chase scene relies on the page design for excitement.

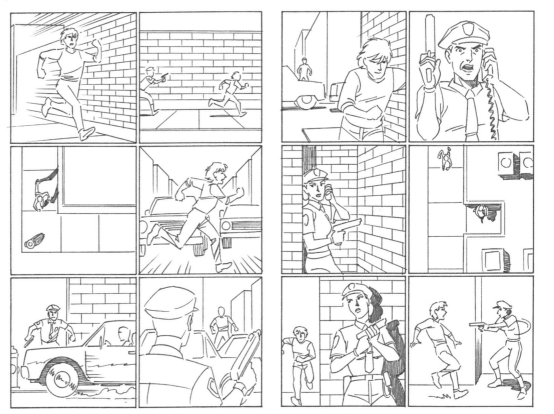

BEGINNER

The beginner uses a typical 6-panel design with no variations. Most of the shots are pretty flat. The overhead shots establish the environment but are hardly dramatic. All of the cuts flow so smoothly that it feels like we're watching a slide show, not an action scene.

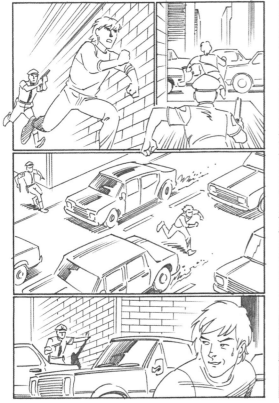

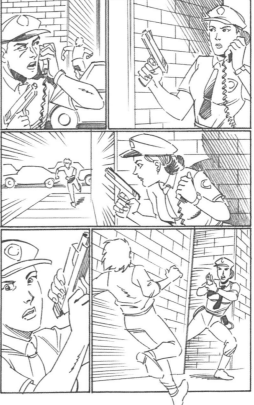

AMATEUR

This is much better than the previous version; it conveys excitement and emotion. The page is no longer locked into the standard 6-panel design. A few borders have been broken, but barely. The shots are drawn at an angle. The artist is very consciously designing a foreground, middle ground, and background into most panels. Note the high angle showing the bad guy running across the intersection; it works much better than the extremely high overhead angle in the previous version, because it puts us in the middle of the action rather than removing us from it.



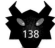

138

PROFESSIONAL

This artist is able to maintain a heightened sense of action and urgency over two pages—no small feat. The characters look like they're really moving. We barely feel able to keep up with the pace of the action. Notice that some of the panels are tilted to undermine the stability of the scene. There are also panels inserted into other panels (called inserts) so that we don't have to slow down to take them in. And, there's excellent use of spotlight panels. These are panels that typically dominate the page. Other panels may bleed into them, creating a sense that the action is happening all at once. The first spotlight panel is the one in which the bad guy dashes across the intersection. The second is the one in which the female cop darts out from the alleyway to confront the bad guy.

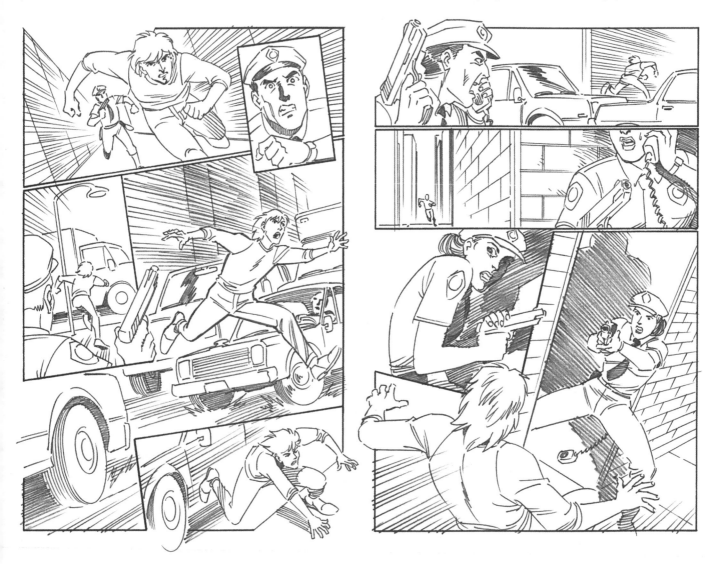

AFTER THE BIG FIGHT SCENE

It's best to use what's called a *time-cut* after a scene with a big gunfight, meaning that the scene following the gunfight should take place a few hours, a day, or even a few days later to indicate a cut in time, hence the term time-cut. After a time-cut, you can reintroduce the character without his or her gun because time will have passed, and the reader will assume that the character has put the gun away in the interim. If you don't have a time-cut and you go right from the gunfight into the next scene in chronological order, you'll be stuck drawing that gun in every shot. (This applies to fight scenes involving other types of weapons, as well.)

Creating Cool Worlds for Your Stories

After you've learned to draw the characters and figured out how to position them in scenes, you need to put them in really cool environments from which they can carry out their evil adventures.

When you write or design a story and characters, you've got to have an overall "world view." Is your world in the present time? Or, is it the year 2433? Perhaps your world is one that has been altered by a 50-year war with a nefarious race of aliens. Maybe it's a society that lives underground to escape the sun, which has turned into a red giant. All of these scenarios lend themselves to very different environments.

When designing a world for your characters, start with the master setting. That's the one where most of the action takes place, where the main characters gather. It's home base for the story. It's also the establishing shot for the series, meaning it establishes *where* and even *when* you are. The other settings branch out from there.

A WORLD AT WAR

Many popular manga stories feature civilizations at war, one good, one evil, with nonstop action. The survival of the Earth hangs in the balance. The military and civilians work together to fend off the invasion. The war room below is the master setting for this type of story. Secondary settings are also below.

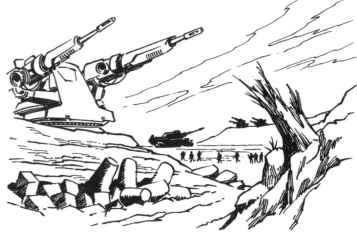

"PERSUASION" ROOM

ANTIAIRCRAFT DEFENSES AND BUNKERS

HOW TO DRAW THE DASTARDLY CHARACTERS OF JAPANESE COMICS

MANGA VILL

CHRISTOPHER HART

MANGA MANIA
VILLAINS